Susanna Partsch

FRANZ MARC

1880–1916

TASCHEN

KÖLN LONDON MADRID NEW YORK PARIS TOKYO

FRONT COVER:
Tiger (detail), 1912
Tiger
Oil on canvas, 111 x 111.5 cm
Munich, Städtische Galerie im Lenbachhaus

ILLUSTRATION PAGE 1:
Lying Bull, 1911
Liegender Stier
Chalk, 11.4 x 15.8 cm
Munich, Staatliche Graphische Sammlung

ILLUSTRATION PAGE 2:
Red and Blue Horse, 1912
Rotes und blaues Pferd
Tempera, 26.3 x 43.3 cm
Munich, Städtische Galerie im Lenbachhaus

BACK COVER:
Franz Marc, around 1912
Photo: AKG Berlin

© 2001 Taschen GmbH
Hohenzollernring 53, D–50672 Köln
www.taschen.com
Editing and production: Brigitte Hilmer, Cologne
English translation: Karen Williams, Cologne
Cover design: Catinka Keul, Angelika Taschen, Cologne

Printed in Germany
ISBN 3–8228–5644–4

Contents

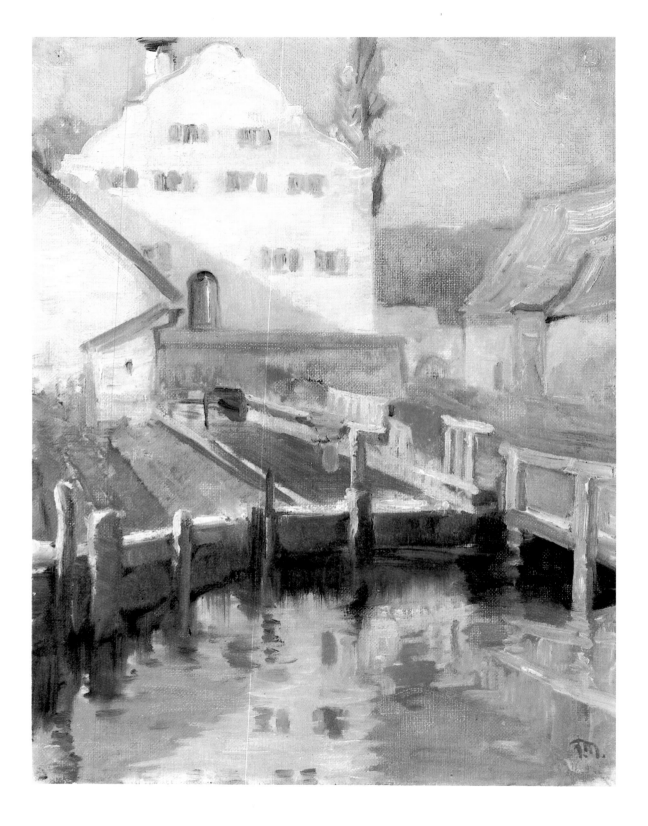

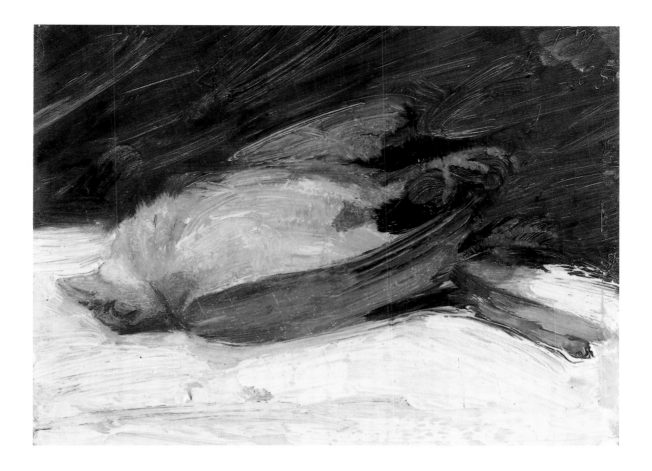

only to go back to Kochel following his return. He began studying horses in the surrounding fields, and sought to capture their movements on canvas. The most important work from this plein-air period is *Two Women on the Hillside,* which shows Marie Schnür and Maria Franck in a meadow. Only a small sketch (p. 13) survives of the original motif, since Marc later cut up the large-format painting. His bright, economical use of colour indicates that Marc was already exploring colour theory, while his rapid, broad brush-strokes aim not at true-to-life representation, but at capturing a situation. The picture is also an important record of his circumstances at the time. His relationship with Maria Franck was already very close and intensive. In this sketch, however, she is seen lying in the background, her hand hiding her face. Marie Schnür, seated in the foreground, looks back at her reclining figure. There is a sense not only of the friendship and the closeness between two women who have known each other a long time, but also of the rivalry between them.

And indeed, Marc married Marie Schnür first! This latter was the mother of an illegitimate child of whom – according to the law of the

The Dead Sparrow, 1905
Der tote Spatz
Oil on wood, 13 x 16.5 cm
Norden, Dr. Erhard Kracht

day – she could only have custody if she was married. Franz Marc declared himself willing to help. Whether he felt strongly attracted to her, too, or whether his relationship with Maria Franck was already the more intense, can today no longer be judged. Later, however, a petition to the court read thus: "At that time Frau Schnür accepted the promise of marriage only with the express observation that Herr Marc retained the freedom to separate from her following contraction of the marriage. This observation can be confirmed by deposition. Frau Schnür knew then and subsequently of the intimate relations between Herr Marc and Frl. Franck. . . Frau Schnür declared that she wished to enter into marriage solely for the sake of her child. . ."[3] The couple were married in March 1907. Marc travelled alone to Paris on the very evening of their wedding.

The Impressionists, who had so profoundly influenced him in 1903, he now saw through more critical eyes. He found them too moderate, and lacking in "fortissimo". In these painters, who had based their art on a scientifically rational way of thinking, Marc missed emotionality. He criticized their "things" as "pictorial", in so far as they never produced the "space and soul-shattering" effect that he claimed as his goal. When he then saw a "colossal collection" of works by van Gogh and Gauguin, he was captivated. To Maria Franck he wrote euphorically that his "faltering, anxiety-ridden soul" had "finally found peace" at the sight of "these wonderful works".

Small Horse Study II, 1905
Kleine Pferdestudie II
Oil on cardboard, 27 x 31 cm
Kochel am See, Franz Marc-Museum
Property of the Bayerische
Staatsgemäldesammlungen

vorce on grounds of adultery. According to the law of the day, she thereby prevented Franz Marc from marrying Maria Franck. The dispute dragged on for years until the couple, who had been living together de facto since 1908 and were married under English law in London in 1911, were finally allowed to marry under German law in 1913.

In the summer of 1908 Maria Franck and Franz Marc worked in Lenggries, with tree studies and horse paintings the results. They painted together outdoors, in a clearing and in the paddocks. *Larch Sapling* (p. 15) of 1908 shows Marc leaning towards van Gogh, a tendency which emerges even more clearly a year later in his *Oak Sapling*. It was in Lenggries that he began painting groups of horses on large-format canvases – a theme which was to occupy him for a long time to come and which he subjected to ever new variations.

The Lenggries paintings from 1908 and those of 1909 from Sindelsdorf, such as *Deer at Dusk* (p. 17), show Marc still striving to find his own language of form. While reducing his subjects ever more rigorously to their bare essentials, he was still unable to free himself from a naturalistic palette. First signs of a more subjective choice of colour do not appear until 1910 and his *Nude with Cat* (p. 22), only to be extensively countermanded in *Grazing Horses I* (p. 25).

In 1909 Franz Marc and Maria Franck spent their first summer in Sindelsdorf. One year later the couple gave up their Munich studios and

Small Horse Picture, 1909
Kleines Pferdebild
Oil on canvas, 16 x 25 cm
Kochel am See, Franz Marc-Museum
On loan from private collection, Munich

moved to Sindelsdorf permanently. Marc was not yet making money from his pictures. He earned his living by giving art classes and selling antiques, activities which robbed him of time and energy for his own painting. Thanks to the help of a painter colleague from his Academy days, however, he managed to sell a few works to the Brakl and Thannhauser art galleries in Munich. A young painter saw two of his lithographs at Brakl's and subsequently visited him in his studio. This meeting between Franz Marc and August Macke, seven years his junior, marked the beginning of a new chapter in Marc's career.

Deer at Dusk, 1909
Rehe in der Dämmerung
Oil on canvas, 70.5 x 100.5 cm
Munich, Städtische Galerie im
Lenbachhaus

Artist friendships and confrontations with colour

1910 marked a turning-point in the life of Franz Marc. He turned his back upon Munich once and for all and withdrew into the seclusion of Upper Bavaria. At long last, too, he made friends with other artists, whose subsequent influence upon his work cannot be underestimated, and took up the cause of "new art" with great vigour. These steps can be clearly traced in his pictures.

The impression which the paintings of van Gogh and Gauguin had made on him during his second trip to Paris was reinforced by an exhibition of van Gogh's works held in Munich in December 1909. Marc helped the two art dealers Brakl and Thannhauser in the hanging of the pictures. This direct contact with van Gogh's paintings enabled him to study their technique and formal language in great detail, and led to a concrete exploration of van Gogh's style of painting, as documented in *Cats on a Red Cloth* (p. 21). Marc's correspondence with Maria Franck reveals that he worked on this picture from late December to early January. Both its intense colours and in particular its broad, powerful and agitated brushwork automatically call to mind the work of van Gogh. Marc applied the latter's stylistic means in particular to the grass and flowers in the background. This picture appeared entirely out of character within the exhibition of Marc's work held in Brakl's gallery in February. It also contradicted expectations raised by the poster which Marc had designed for the exhibition (p. 19). This again showed two cats, their movements captured in a masterly fashion. They nevertheless still lacked the restriction to essentials which Marc now increasingly strove to achieve.

In another painting from 1910, *Nude with Cat* (p. 22), Marc processed yet another set of impressions – derived in this case from Henri Matisse (1869–1954) and Paul Cézanne (1839–1906). The treatment of the figure recalls Cézanne, while the colouring owes more to the influence of Matisse. The exploration of spectral colours and experimentation with a subjective palette which Marc was then pursuing find their expression in this painting. He nevertheless avoids broad areas of colour, leaving the picture restless and the individual sections lacking cohesion.

The search for a personal style can be clearly traced through the paintings of the next two years. But Marc was seemingly not yet able to transform the ideas in his mind into images on canvas. His orientation to-

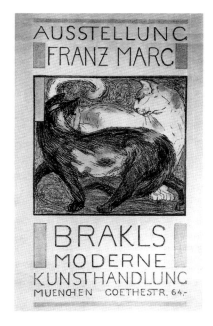

Two Cats, 1909/10
Zwei Katzen
Poster for the Franz Marc exhibition at Brakl's art gallery, Munich, February 1910
Lithograph, 40.5 x 42 cm
Munich, Städtische Galerie im Lenbachhaus

Blue Horse I, 1911
Blaues Pferd I
Oil on canvas, 112.5 x 84.5 cm
Munich, Städtische Galerie im Lenbachhaus

wards the stylistic means of artists who fascinated him should not, however, be misunderstood as mere copying. These were tentative attempts to portray the world of his own imagination. *Nude with Cat* simply represents one, less successful solution.

It thus seems understandable that Marc should greatly modify this subjective choice of colouring in *Grazing Horses I* (p. 25). In terms of their movements and "expression", Marc here reduces his portrayal of the horses to essentials, rejecting naturalistic illustration in favour of emphasis upon one fundamental characteristic and one action. But in his choice of lighter, low-contrast shades of brown and yellow, mixed with a little blue and a lot of white, he returns to the more true-to-nature palette of his earlier works.

All the more astonishing, then, is the *Horse in a Landscape* (p. 30) from the very same year. Broad slabs of colour dominate the picture. In the foreground, a bay horse with a blue-black mane looks into the picture at a bright yellow field interspersed with patches of green. Only through the presence of the horse are we led to see a cornfield and green shrubs in these sweeps of colour. In its powerful, strongly-contrasting areas of colour the painting radiates a tranquility and harmony previously unseen in Franz Marc's oeuvre.

After five years of searching, of assimilation of the Impressionists, of the fathers of Expressionism – as van Gogh and Gauguin are repeatedly called – and, finally, of the Fauves, the "wild beasts" centred around Matisse, Marc's painting had undergone a stylistic development which led, within just one year, to the emergence of his very own style. This is clearly revealed by the comparison of two, thematically related pictures such as the *Deer at Dusk* (p. 17) of 1909 and *Deer in the Snow* (p. 27) of 1911. Both paintings show two deer, one with its head lowered to the front and the other, sensing danger, twisting its head to the rear. The animals are situated in an indeterminate setting, the former in a meadow and the latter in snow. Thus far the pictures sound very much the same. Their similar subjects are, however, transformed through palette and style into two paintings entirely different in structure. The earlier version is dominated by broken hues of white and brown. Animals and background are composed of short, broad brush-strokes. The clumps of grass appear to consist of small, flickering flames, creating a certain sense of agitation.

In contrast, the brushwork of the later painting is regularly layered and applied in flat surfaces. Blue-green holes bore into large white mountains of snow. They form the backdrop to the reddish-yellow deer whose bodily structure is now only suggested. The simplification and limitation of forms to essentials, an approach also adopted in the earlier work, is here executed in large areas of pure colour and results in a calmer and more harmonious atmosphere. The pictorial aim has changed. While in the first picture the superficial prevails, Marc had now found a way of painting the "inner, spiritual side of nature".

The processes thus described – Marc's free use of colour, his modification of the formal structures of a picture and the self-confidence with

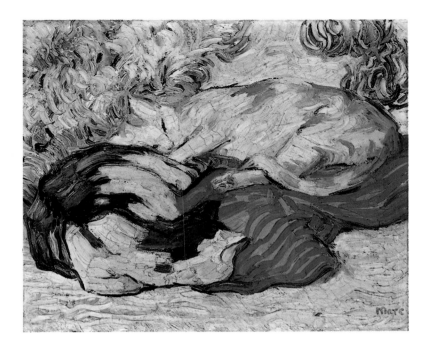

Cats on a Red Cloth, 1909/10
Katzen auf rotem Tuch
Oil on canvas, 50.5 x 60.5 cm
Private collection

which he now pursued his art – owe a great deal to the new contacts which Marc had meanwhile established. But while these contacts were a precondition of his artistic development, Marc's personality and the stimuli that he received were inextricably interlinked.

Thus it was that the first meeting between Macke and Marc took place at the instigation of Macke who, coming face to face with a small number of Marc's prints in January 1910, had felt the immediate urge to make the artist's acquaintance. The details of this first encounter between Franz Marc and August Macke are described both by Marc in a letter to Maria Franck and by Macke's cousin, Helmuth Macke.

The then twenty-three-year-old Macke, normally resident in Bonn, was at that time spending a year with his young wife at the Tegernsee. At the beginning of January 1910 he travelled with his cousin Helmuth, also a painter, and his wife's cousin, Bernhard Koehler junior, to Munich, where the three wanted to visit some art dealers. Koehler came from Berlin and was the son of the wealthy manufacturer and art patron Bernhard Koehler senior.

In Brakl's gallery, August Macke and his two companions came across two lithographs by Marc which so excited them that they asked Brakl for the artist's address. Shortly afterwards they were standing in his studio in the Schellingstrasse. The significance of this visit for Marc grew with the realisation that for the first time he was meeting people who thought and felt as he did. He felt particularly drawn to August Macke. Together with Maria Franck he spent several days at the Tegernsee just a few weeks later, and the friendship between the two painters

was sealed. Once more back in Munich, Marc wrote to Macke: "I consider it a real stroke of luck to have at last met colleagues with such inner-oriented artistic convictions – rarissime! How delighted I should be were we one day able to compare pictures."[5] At that time Marc had not yet seen any of his friend's paintings, but only his drawings.

The friendship between the two artists is documented in an intensive and illuminating exchange of correspondence. In their letters they discussed their methods of working, criticized – with what today seems astonishing frankness – pictures by the other not to their liking and remained, despite all their differences of opinion in questions of art and cultural policy, close personal friends.

At Brakl's, Koehler Jr. not only purchased a lithograph by Marc but requested the gallery owner to send a number of Marc's pictures on approval to his father in Berlin. Koehler Sr. subsequently travelled down to Munich at the end of January and visited Marc in his studio. There he discovered *The Dead Sparrow* (p. 11), a painting which Marc himself valued dearly and which always stood on his desk. Marc had regularly maintained it was not for sale. When Koehler offered him a hundred Marks, however, Marc bowed to the pressure of the financial difficulties in which he currently found himself and sold the picture. It was to become the cornerstone of the extensive Marc collection which Bernhard Koehler was later to own and which – with the exception of those works destroyed by fire in the Second World War – can today be seen in the Städtische Galerie im Lenbachhaus in Munich. Soon after Marc had moved permanently to Sindelsdorf he went to Berlin to view Koehler's collection. It was here that he saw paintings by August Macke for the first time. Back in Sindelsdorf, he wrote to his friend: ". . . and everything else of yours hanging there reveals the splendid artist I had always suspected and hoped for from your sketchbooks. . . The Koehler collection contains some magnificent pieces. But it urgently needs reshaping if it is to delight as a whole. We should both do our best to ensure it looks different in five years' time."[6]

Marc was here able to speak with such self-confidence due to the fact that Koehler had arranged to pay him – provisionally for a one-year period – a monthly two hundred Marks in return for paintings to the equivalent value which he could choose himself. Koehler had also bought a number of paintings from Brakl's Munich exhibition, including *Cats on a Red Cloth* (p. 21). Marc was thus now relieved of financial cares – probably another reason for the rapid development, described above, which his painting now underwent. Marc was at last able to work uninterrupted, to concentrate entirely upon his pictures. He spent the summer painting in Sindelsdorf. His friendship with Macke, who was not to return to Bonn until late autumn, grew closer. They visited each other, met in Munich and exchanged ideas, thoughts and books. In autumn that year Marc finally established contact with the Neue Künstlervereinigung - New Artists' Association – in Munich.

This association, which had been founded in January 1909 and whose members included Wassily Kandinsky, Alexei von Jawlensky

Nude with Cat, 1910
Akt mit Katze
Oil on canvas, 86.5 x 80 cm
Munich, Städtische Galerie im
Lenbachhaus

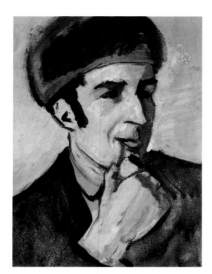

August Macke
Portrait of Franz Marc, 1910
Bildnis Franz Marc
Oil on cardboard, 50 x 39 cm
Berlin, Staatliche Museen Preußischer
Kulturbesitz, Nationalgalerie

(1864–1941), Gabriele Münter (1877–1962) and Marianne von Werefkin (1860–1938), held its first exhibition in December of that year at Thannhauser's gallery. Although Marc was greatly impressed by their works at the time, he felt no call to make contact with the artists themselves. He clearly did not yet feel they had enough in common to make a meeting worthwhile.

The group's second exhibition took place in September 1910 and provoked controversial reviews from the public. Marc went to the show during its first few days and was enthralled; he responded to the criticism which he had apparently overheard during his visit in a long letter, in which he blamed the negative reaction of the public on its conservative visual tastes ("it wants easel painting") and sought to explain in words the novelty of these pictures: "The utterly spiritualized and dematerialized inwardness of feeling which our fathers. . .never even attempted to explore in a 'picture'. This bold attempt to spiritualize the 'subject' in which Impressionism was so utterly engrossed is a necessary reaction. . . What seems so promising in the new work being done by the 'New Artists' Association' is that, in addition to their supremely spiritualized tenor, its pictures contain outstanding examples of spatial organization, rhythm and colour theory." Having demonstrated how the individual artists had progressed beyond traditional painting, Marc continued: "Their logical distribution of the plane, the mysterious lines of the one and the colour harmony of the other seek to create spiritual moods which have little to do with the subject portrayed but which prepare the ground for a new, highly spiritualized aesthetic. . ." and concluded with the words: "Everyone with eyes in their head must here recognize the powerful trend of new art."[7]

These quotations reflect Marc's thoughts on the function he felt art should have. The "spiritual", a concept he never defined more closely, thereby played a fundamental role. His ideas are particularly important in view of the fact that Kandinsky had by then completed work on his programmatic essay, "Über das Geistige in der Kunst" (Concerning the Spiritual in Art). With Marc's help this was eventually published at the end of 1911. The remarkable similarities in their theoretical starting-points explain the enthusiasm with which Marc's letter was received by the New Artists' Association and the intensive contact which soon followed.

Marc sent his review to the publisher Reinhard Piper, whom he had known for some months, and asked him to pass it on. Thus it reached the hands of the artists themselves. Not long afterwards, a devastating review appeared in the "Münchner Neuste Nachrichten". From this readers learned "that most of the members and guests of the Association are incurably insane" and that the exhibition was "concentrated madness". The Association asked Marc for permission to print his letter, next to the review from the "Münchner Neuste Nachrichten", in a brochure to be sold at the exhibition venues still to come. Contact was thus established.

Marc soon made the acquaintance of a few Association members (Adolf Erbslöh and Alexander Kanoldt, followed a little later by Ma-

Grazing Horses I, 1910
Weidende Pferde I
Oil on canvas, doubled, 64 x 94 cm
Munich, Städtische Galerie im
Lenbachhaus

rianne von Werefkin and Alexei Jawlensky). In January 1911 he at last
met Kandinsky himself. He wrote enthusiastically to Maria Franck:
"Kandinsky surpasses everyone. . .in terms of personal charm; I was ab-
solutely captivated. How much I look forward to introducing you to
these people! You will feel immediately at home. . ."[8]

In February 1911 Marc became a member, and was simultaneously
elected a member of the board. This marked the start of a period of in-
tense involvement in current cultural affairs which was to take up a great
deal of time and space in Marc's creative career.

Marc had already been studying colour theory for quite some time,
albeit without querying the traditional rules governing the use of com-
plementary colours. In the winter of 1910/11 he returned to these studies,
but now with his own ideas and aims in mind. The impetus for this move
came from two sides.

In December 1910 he told Maria Franck of his experiments with col-
our, and mentioned Marianne von Werefkin's remark that Germans all
made the mistake of taking light to be colour, whereas colour was in fact
something quite different. This had spurred him to investigate colour phe-
nomena more closely. At the same time, however, his experimentation
was also inspired by the pictures of Macke. The correspondence between
Marc and Macke over the course of this winter not simply documents

Marc's own thoughts, but shows both artists profiting from the discoveries of the other. It was thus not a case of one acting as spiritus rector, but of both providing regular mutual inspiration until finally their understanding of painting had developed so far apart that only mutual acceptance was possible. But that point would not be reached until later.

They began exchanging thoughts on colour in December 1910. Macke had just started exploring the parallelism of colour and music and assigned sad sounds to the colour blue, cheerful sounds to yellow and brutal sounds to red. He wrote to his friend: "The borders of yellow, red and blue merge into orange, violet and green, whereby lightening corresponds to ascending notes on the piano, whereby the quantity of piano octaves. . .corresponds to the number of concentric circles."[9] Macke, who had clearly made himself a colour circle of primary and secondary colours, asked Marc in the same letter to give him his own thoughts on the subject. He explained that he was studying colour theory because he considered it important "to get to the bottom of all painting laws, in particular to relate the most modern to the oldest, in order to be able to express oneself naïvely with art".

Marc replied a few days later. He rejected the colour circle because the complementary colours only ever met in the middle and it was never possible to see them side by side. He then described to his friend his view of the primary colours and the characteristics he felt they incorporated: "Blue is the male principle, stern and spiritual. Yellow the female principle, gentle, cheerful and sensual. Red is matter, brutal and heavy and always the colour which must be fought and vanquished by the other two!"

Having discussed the secondary colours of green, violet and orange which arise from the respective mixing of two primary colours, and their relationship to the complementary colours – "blue and orange, a thoroughly festive sound" –, he returned to the relationship between the primary colours themselves: "Despite all spectral analysis, I can't abandon my painter's belief that yellow (woman!) is closer to earth red than blue, the male principle."

He emphasized that he did not rate all colours the same and that he found relationships between complementary colours much less complicated than those between colour masses. "It is not hard to grasp that blue is related to orange, but when it comes to what mass blue can have next to orange in each individual case – that's where the rot sets in. That's what the wretched theories leave out. . ." Marc was also sceptical about the relationship between colour and music, but asked his friend to demonstrate it on his next visit.

This was clearly a period in which both artists were preoccupied with finding their "own" style, for they exchanged long and detailed letters about various colour theories and composition systems. Marc read endless books on colour theory and was astonished to note: "I am surprised above all by the unbelievably theoretical contradictions prevailing among intellectuals regarding these few spectral colours. But I have found some interesting things."

Deer in the Snow, 1911
Rehe im Schnee
Oil on canvas, 84.7 x 84.5 cm
Munich, Städtische Galerie im Lenbachhaus

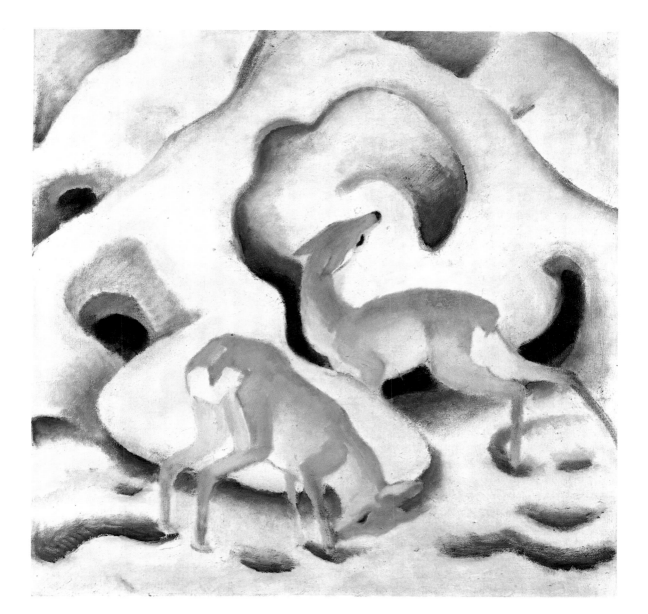

In another letter to Macke of 14 January 1911, he wrote down some of the fundamental ideas having a direct influence on his painting. These reveal the process in the course of which he developed the style of painting which characterizes the most important part of his oeuvre. An important event in this context was a concert by Arnold Schoenberg (1874–1951) which he attended together with the members of the Artists' Association and which represented his first exposure to twelve-tone music. "Can you imagine a music in which tonality (i.e. the adherence to a key of any kind) is completely precluded? I was constantly reminded of Kandinsky's great composition, which similarly permits no trace of tonality. . . Schoenberg starts from the principle that the concepts of consonance and dissonance simply do not exist. A so-called dissonance is simply a consonance further apart." Marc applied this idea to colours, and concluded that it was not imperative to obey traditional colour laws: "It is by no means necessary to have complementary colours appear in the order they follow in the prism; rather, they can be 'distanced' as far as you like. The partial dissonances which thereby arise are neutralized in the appearance of the whole picture, have a consonant (harmonic) effect, in so far as they are complementary in their distribution and strength."

Although Marc now also saw a relationship between painting and music, he did not, like Macke, equate notes with colours. Rather, he compared colour theory and music theory and, having experienced innovations in the latter, saw an opportunity to restructure the former.

The relationship between painting and music which the two artists were seeking can also be explained by the prominent role which music played in both families. Both Lisbeth Macke and Maria Franck were accomplished pianists and followed with interest the modern currents in music. Maria Franck thus obtained copies of Schoenberg's music in order to study it in greater depth at the keyboard. This in turn profited Franz Marc. The Schoenberg concert provided him with a profound confirmation of his own belief that a new form of painting could only be reached by transcending the intellectual bases which had previously determined the central European world picture: ". . .our ideas and ideals must wear a hair shirt; we must feed them with locusts and wild honey, and not with history, in order to escape our tired European lack of taste."

These were ambitious words which have yet to become reality even today. Marc, moreover – whether consciously or unconsciously –, himself used thoroughly traditional forms and subjects in his painting.

Macke, who rarely wrote at length, did not go into Marc's programmatic letters in depth, but asked for more specific details about how Marc employed the prism. Marc's reply provides an interesting insight into his handling of colour. Marc used the prism "to check the purity of effect of his painted colours in their juxtapostion". He could achieve this better with the prism than with the naked eye. He explained the practical procedure to Macke in the example of *Dog Lying in the Snow* (p. 29), a painting he had clearly just completed:

"I painted Russi lying in a field of snow; I made the snow pure white

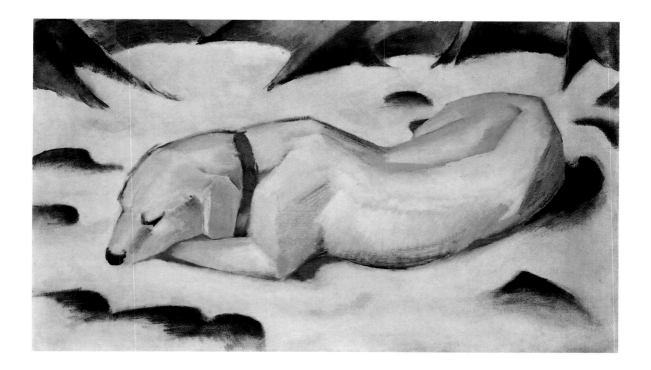

Dog Lying in the Snow, 1910/11
Liegender Hund im Schnee
Oil on canvas, 62.5 x 105 cm
Frankfurt, Städelsches Kunstinstitut

with hollows of pure blue, the dog dull yellow. In the prism the yellow appeared opaque grey, the whole dog encircled by the most fantastic rings of colour. Step by step, I now made the dog 'pure-coloured' (light yellow); each time the colour became purer, the coloured edges around the dog disappeared a little more, until finally a pure colour relationship was created between the yellow, the cold white of the snow and the blue within it. Furthermore, the blue must not take up too much space in relationship to the pure but weak yellow if it is to remain complementary (i.e. justified, 'organized')."

This description casts clear light on Marc's method of working and at the same time explains why the juxtaposition of pure colours in a painting is by no means as simple as it may seem to the viewer. For the artists of Marc's day, who had come from a school which had taught them to employ subdued colours, the use of pure, clear colours had to be learned through wearisome trial and error.

Direct links between the passages from Marc's letters quoted above and his paintings can be seen, for example, in his *Blue Horse I* (p. 18), *The Bull* (p. 32), *The Yellow Cow* (p. 40) and of course *Dog Lying in the Snow* (ill., p.29), for which his dog Russi had served as model.

In 1911 Marc's newly-established contact with Kandinsky was intensified. Kandinsky was a frequent guest at Gabriele Münter's house in Murnau, near enough to allow mutual visits on foot or by bicycle. The correspondence between Marc and Kandinsky documents their work

together and the alliance between them. At the same time, however, its professional tone indicates that their relationship never grew to include the warmth and affection which always carried the day in Marc's correspondence with Macke, even during their most animated arguments. This new friendship precipitated great changes in Marc's life. Although living in the seclusion of Sindelsdorf, he now became active in cultural affairs, an occupation which took up a good deal of his time. He helped arrange for Kandinsky's manuscript, "Concerning the Spiritual in Art", to be printed by Reinhard Piper. It appeared at the end of 1911. He also played a large part in the reaction to the so-called "Vinnen Protest".

Following the purchase of a van Gogh picture by the Bremen Kunsthalle in April 1911, Worpswede painter Carl Vinnen had started a protest against the foreignization of German art, attracting the support of numerous and indeed well-known artists such as Thomas Theodor Heine, Franz von Stuck, Wilhelm Trübner and Paul Schultze-Naumburg, who was subsequently to enjoy such success under the National Social-

Horse in a Landscape, 1910
Pferd in Landschaft
Oil on canvas, 85 x 112 cm
Essen, Museum Folkwang

"The other morning I walked over to Kandinsky's! The hours spent with him belong to my most memorable experiences. He showed me a great deal. . . my initial response is to feel the great joy of his powerful, pure, fiery colours, and then my brain starts working; you can't get away from these pictures and you feel your head will burst if you want to savour them to the full. . ." *Franz Marc, 10.2.1911*

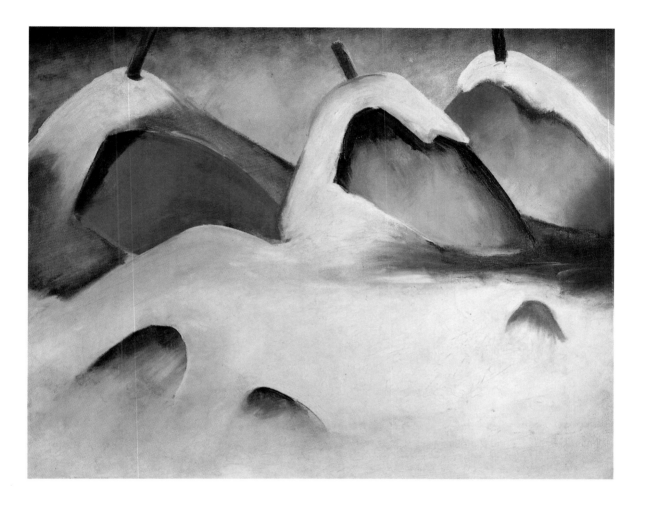

Stooks in the Snow, 1911
Hocken im Schnee
Oil on canvas, 79.5 x 100 cm
Kochel am See, Franz Marc-Museum
Franz Marc estate

ists with his "racial art theory". Astonishingly, even Käthe Kollwitz was among the signatories.

Vinnen's "Ein Protest deutscher Künstler" (A Protest by German Artists) appeared first in sections in German daily newspapers and then as a pamphlet. Marc and Kandinsky had independently decided to launch a counterattack, and subsequently together organized "Im Kampf um die Kunst" (The Battle for Art), a paper in which famous museum directors, art historians and artists stated their views. "The Battle for Art" appeared through Piper that summer.

In his own contribution, Marc wrote: "A strong wind is today blowing the germs of a new art across all of Europe, and wherever there is good, fresh earth they will spring up of nature's accord. The anger of a number of artists on German soil that the wind is currently from the west seems truly ridiculous. They would prefer a calm. For nor do they want an east wind, since the same new seeds are blowing in from Russia. What can be done? Nothing. The wind goes where it will. The seed

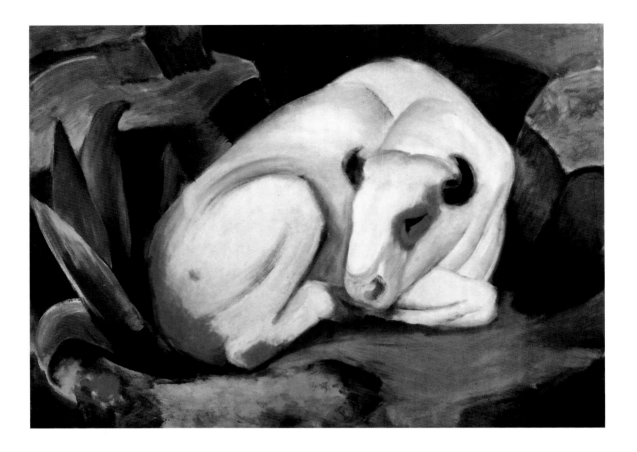

stems from the abundance of nature; even if you tread on a few plants, or pull them up, it will make no difference to nature. It is merely a little uncooperative, and betrays a sad attitude to art. There is only one means of agreement: honest comparison."[10]

It was the first time that Franz Marc had undertaken such a large-scale campaign. There were letters to be written, individuals to be approached. The negotiations with Reinhard Piper were chiefly his responsibility. In December Kandinsky, Marc and Münter resigned from the New Artists' Association. The reason was almost incidental – any other would have served just as well. Kandinsky had submitted a picture for the next exhibition which was too large to be accepted without approval by the jury. It was naturally rejected.

Kandinsky had already vacated his seat on the board back in January, following clashes of principles among the members. In August Marc wrote to Macke that Kanoldt's new works had greatly depressed him, and conjectured (with Kandinsky) that the next jury would produce a split. It was not, however, certain whether Jawlensky and Werefkin would take their side at the decisive moment, namely in a crucial vote which would force the others to leave the Association. Marc's fears were

The Bull, 1911
Der Stier
Oil on canvas, 101 x 135 cm
New York, Solomon R. Guggenheim
Museum

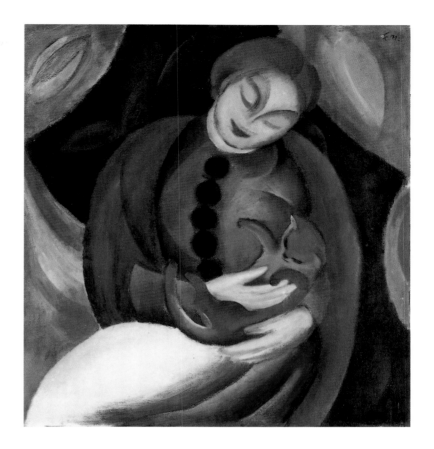

Girl with Cat II, 1912
Mädchen mit Katze II
Oil on canvas, 71.5 x 66.5 cm
Private collection

PAGE 34/35:
The Little Yellow Horses, 1912
Die kleinen gelben Pferde
Oil on canvas, 66 x 104.5 cm
Stuttgart, Staatsgalerie

confirmed. While Marianne von Werefkin in particular spoke in Kandinsky's defence, neither she nor Jawlensky took any further stand following the rejection of his picture, but remained members of the Association – albeit only for one more year.

Brevity was a typical characteristic of all the artists' associations of the day. Artists everywhere were rallying against conventional academy art, but without possessing a common platform. The differences in their artistic beliefs gradually emerged over time and often resulted in unpleasant disagreements leading sooner or later to the resignation of one or both parties. One such dispute had already arisen – albeit only after eight years – in the Vienna Sezession, in the course of which those artists who had been most responsible for the development of the Sezession lost the crucial vote and were forced to resign. Events in Munich now took a similar turn, the difference being that the New Artists' Association had existed for a bare three years, and Franz Marc had been a member for just ten months.

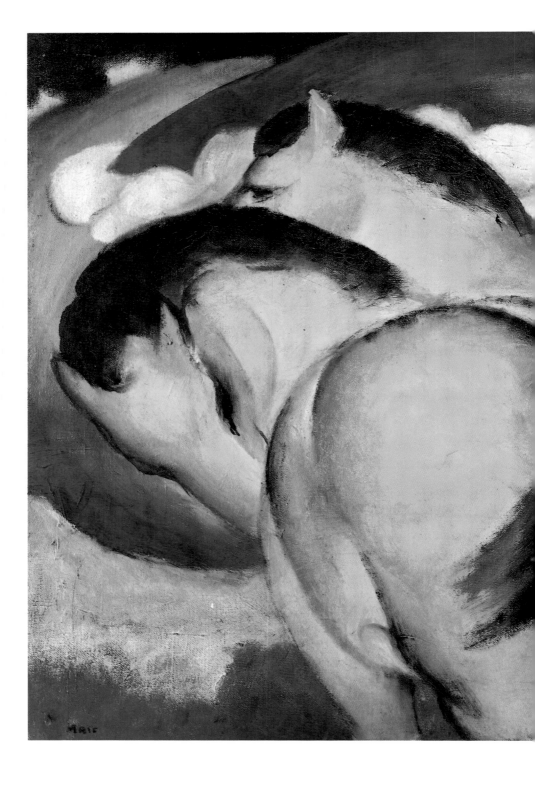

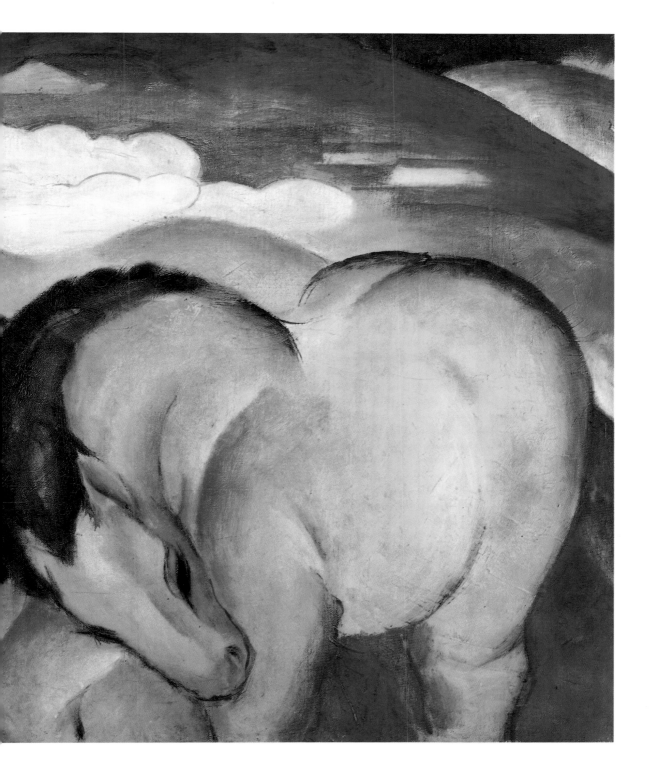

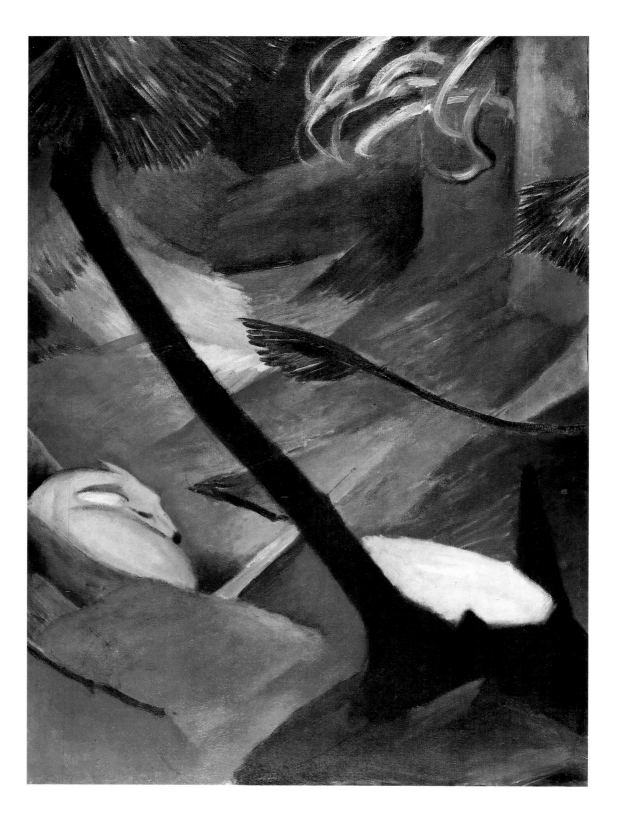

The animal painting –
alien or anthropomorphic?

On 3 July 1989 the Süddeutsche Zeitung carried the following report:
"The highest price ever reached by a work of art at a German auction
went to the tempera *Fabulous Beasts* by Franz Marc at the 9th Villa
Griesebach auction in Berlin. Painted in 1913, measuring just 26.5 x
30.5 centimetres and monogrammed in ink, the picture was knocked
down for 2,600,000 Marks net. . . It had been estimated to fetch. . .a
maximum of 600,000 Marks." (p. 74) Only in September 1980 had "art"
magazine observed that the "Marc boom" of the fifties and sixties was
on the wane.

It is true that the reproductions which once decorated living rooms
and textbooks alike have since disappeared. The result of the auction
shows, however, that Franz Marc is still well and truly in fashion.

His blue horses, white and yellow cows and red deer continue to
move the viewer today. Far from introducing any sense of distance,
Marc's pictures draw the spectator into the world of their animal pro-
tagonists. This was no doubt among the reasons why Marc's paintings
became so popular after 1945. The regularly-cited "pent-up demand" left
by the anti-modernism of the thousand-year Reich did not in fact extend
to the whole spectrum of modern art, nor did it embrace every artist con-
demned as degenerate by the famous exhibition of 1937. There was still
no market for abstract, Dadaist or even sociocritical pictures. Pent-up de-
mand was limited to blue horses and sunflowers and thus basically to a
means of escape from reality. The most popular painters in this field
were frequently given an unfairly one-sided showing. Thus school books
and ranges of reproductions contained no abstract paintings by the mas-
ter of *The Tower of Blue Horses*, but simply his blue horses and red deer.

While the work of Franz Marc contains many other vital elements,
the escape from reality undoubtedly plays an important role in his animal
paintings in particular. The fact that the viewer senses no distance, is
drawn into and moved by the picture, Marc achieves via certain stylistic
means of which he is in part unaware. He himself always claimed to
paint his animals from the standpoint not of the human but of the animal.
In this the animal-loving Marc – inseparable from his dogs even as a boy
– had received his first encouragement from the animal painter Jean Bloé
Niestlé, who later lived alongside Marc and the Rhenish painter Heinrich
Campendonk (1889–1957) in a sort of small artists' colony in Sindels-

Frolicking Horses, 1912
Springende Pferdchen
Woodcut, 13.2 x 9 cm
Munich, Städtische Galerie im
Lenbachhaus

Deer in the Woods II, 1912
Reh im Wald II
Oil on canvas, 110.5 x 80.5 cm
Munich, Städtische Galerie im
Lenbachhaus

dorf. It was he, we may recall, who first gave Marc the idea of imagining himself, for artistic purposes, inside the "soul" of the animal.

From 1910 onwards Marc made regular references to the animal and art in his published writings and personal papers. He formulated his thoughts with greater clarity with each passing year. In 1910, at the request of publisher Reinhard Piper, he wrote a short text entitled "On the Animal in Art". It was published alongside his bronze horse group of 1908/09 in the book *Das Tier in der Kunst* (The Animal in Art) written by Piper himself. Here Marc was quick to distance himself from conventional animal painting: "My aims lie not in the direction of specialized animal painting. I seek a good, pure and lucid style in which at least part of what modern painters have to say to me can be fully assimilated. I. . .am trying to achieve a pantheistic empathy with the throbbing and racing of the blood in nature, in trees, in animals, in the air. . ." He criticized the old easel painting and acknowledged the French who had gone beyond it, starting from Delacroix right up to the Pointillists. He was nevertheless surprised to note that they had systematically avoided the genre so close to his own heart, namely the animal painting: "I see no happier vehicle for the 'animalization of art' than the animal painting. I employ it for this reason. In a van Gogh or Signac everything has become animal – the air, even the rowing-boat on the water, and above all painting itself. Such pictures bear absolutely no resemblance to what used to be called 'pictures'." For Marc, his horse group sculpture was "a tentative step in the same direction". He thereby wanted to preclude the possibility of viewers merely asking after the breed of horse portrayed; they were instead "to feel the inner-trembling animal life".[11]

Eighteen months later the artist was formulating his ideas in considerably more radical terms – albeit in writings not destined for publication: "How does a horse see the world, how does an eagle, a deer or a dog? How impoverished, soulless is our convention of placing animals in a landscape familiar to our own eyes rather than transporting ourselves into the soul of the animal in order to divine its visual world." And again: "What does the deer have in common with the world we see?

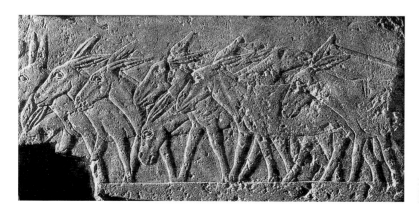

Donkey Frieze
Egyptian, around 2700–2600 B.C.
Leiden, Rijksmuseum

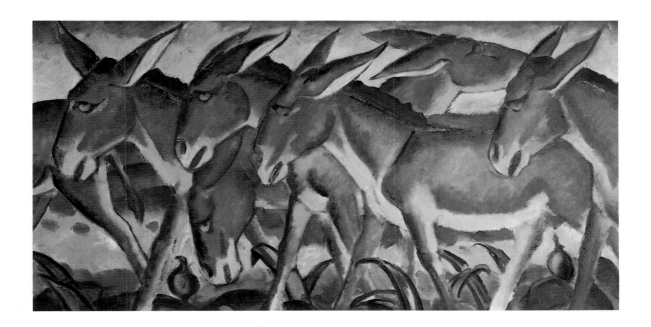

Donkey Frieze, 1911
Eselfries
Oil on canvas, 81 x 150 cm
Private collection

Does it make any reasonable or even artistic sense to paint the deer as it appears on our retina, or in the manner of the Cubists because we feel the world to be cubistic? Who says the deer feels the world to be cubistic? – it feels it as a deer, and thus the landscape must also be 'deer'. . . I could paint a picture called "The Deer". Pisanello has done just that. But I may also want to paint "The Deer Feels". How infinitely more refined a sensitivity must a painter have to paint that!"[12]

In 1912/13, again in his private writings, he noted a number of points on abstract art and the limits of art. Here, too, he concentrated upon the animal: "We will no longer paint a forest or a horse as we like them or as they seem to us, but as they really are, as the forest and the horse feel themselves to be, their absolute essence which lives beneath the semblance which we see." From this vision he concluded: "From now on we must stop thinking of animals and plants only in relation to ourselves and stop portraying them from our point of view in art. That belongs to the past, must be left in the past and one day – O happy day! – will indeed be the past."[13]

During the War he summarized his thoughts on art once more in a letter to Maria Marc. On 12 April 1915 he wrote: "I think a lot about my own art. My instincts have so far guided me not too badly on the whole, even though my works have been flawed. Above all I mean the instinct which has led me away from people to a feeling for animality, for 'pure beasts'. The ungodly people around me (particularly the men) did not arouse my true feelings, whereas the undefiled vitality of animals called forth everything good in me. . . I found people 'ugly' very early on; animals seemed to me more beautiful, more pure."[14]

"We are today experiencing one of the most important moments in the history of civilization. All the 'ancient' culture we still trail along with us (religion, monarchism, aristocracy, privileges (including purely intellectual ones), humanism etc.) is a 'present which already belongs to the past'. . . No one can yet say what sort of new culture we are heading towards, because we ourselves are caught in the middle of change; for the future age, in which all concepts and laws will be given new birth, we modern painters are hard at work to create a 'new-born' art. This must be pure and fearless enough to admit 'every possibility' the new age will offer." *Franz Marc, 21. 1. 1911*

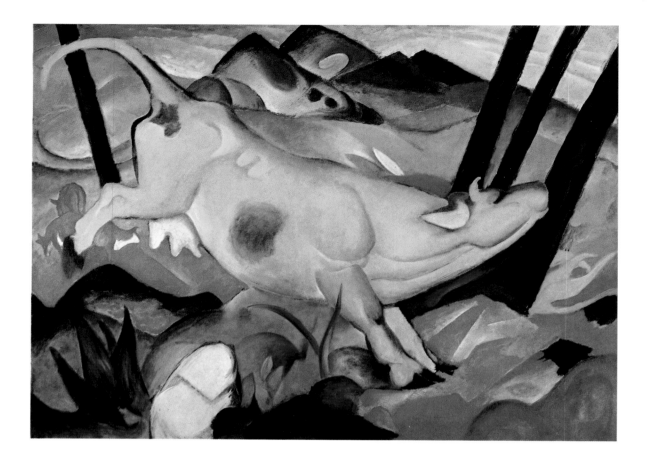

Marc's intensive preoccupation with the portrayal of the animal sprang from his emotional bond with animals. Russi, his large Siberian sheepdog, accompanied him virtually everywhere and appears in many paintings. There were cats in the Marc household as from the move to Sindelsdorf, if not earlier, and Marc later fulfilled his long-cherished dream of owning two deer, which he called Schlick and Hanni.

He sought to achieve his aim of imagining himself within the animal, of painting it not through human eyes but from the animal's own perspective, by making detailed observations in paddocks and pastures. During visits to his parents-in-law in Berlin he also made regular trips to the zoo.

His study of modern painting, and the widespread and repeatedly formulated demand heard at the beginning of the century that objects should be painted not as we see them but as they really are, must have stimulated his efforts not simply to paint animals in the conventional sense but instead to render their feelings. However, he thereby disregarded our common tendency to anthropomorphize the animal, which no doubt arises from the impossibility of transporting ourselves into a

The Yellow Cow, 1911
Die gelbe Kuh
Oil on canvas, 140 x 190 cm
New York, Solomon R. Guggenheim
Museum

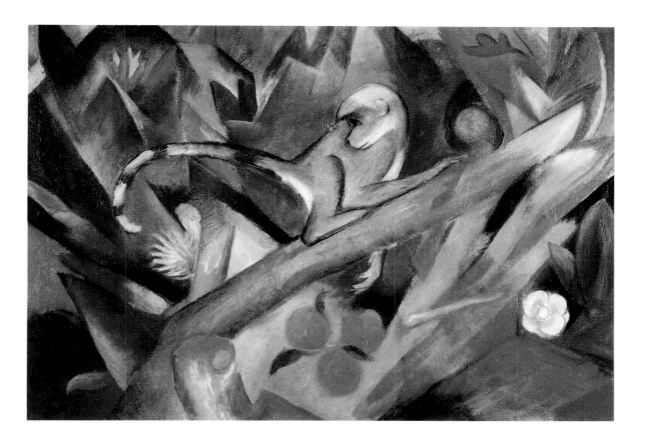

The Monkey, 1912
Das Äffchen
Oil on canvas, 70.4 x 100 cm
Munich, Städtische Galerie im
Lenbachhaus

foreign life form. Reports by contemporaries point to Marc's own humanization of the animal. In his recollections of the painter, for example, Wassily Kandinsky wrote: "There Marc showed me his deer, which he adored as if they were his own children. . ." Not without significance here – however irrelevant for Marc's work as a whole – is the fact that Franz and Maria Marc were to be denied the children for which, as the correspondence between Maria Marc and Lisbeth Macke reveals, they were hoping. Thus the animals became the children he never had. Paul Klee described Marc's relationship with animals more generally and yet more accurately when, following Marc's death, he noted in his diary: "He is more humane, he loves more warmly, more pronouncedly. He has a human affection for animals. He raises them to his own level."

Klee had not intended to interpret Franz Marc's oeuvre in these words. His diary entry was inspired far more by a comparison between his dead friend and himself. Nevertheless – or perhaps for this very reason –, these few spontaneous remarks say a great deal about the animal in Marc's paintings. From an art-historical point of view it has recently been convincingly demonstrated that Marc based his animal paintings, al-

beit probably unconsciously, on typical figure compositions. This explains why it is difficult to view his pictures with detachment. His concern to imagine himself within his animal subjects led Marc to anthropomorphize them and, in most of his paintings, to portray human feelings, if not indeed himself.

When approaching his work from this angle, it is also important to remember the colour symbology that Marc had developed for his compositions. Thus the *Blue Horse I* (p. 18) of 1911 becomes, like *The Dead Sparrow* (p. 11) of 1907, a portrayal of the artist himself. "Blue is the male principle, stern and spiritual", Marc had written to Macke. For Marc, horses were clearly frequently linked to the male principle. Here the horse, dominating the compositional foreground, stands squarely on its four legs. Its head is inclined somewhat to one side as it looks thoughtfully downwards. The hilly landscape is treated in highly abstract terms. A stylized plant in the foreground, its middle leaf growing steeply upwards, forms the sole reference to living nature as we customarily perceive it. The landscape contains all the colours of the chromatic circle – yellow, green, blue, red, a light violet and orange. These reinforce the blue of the horse, create a melodious colour harmony and induce the pro-

Red Deer II, 1912
Rote Rehe II
Oil on canvas, 70 x 100 cm
Munich, Staatsgalerie moderner Kunst

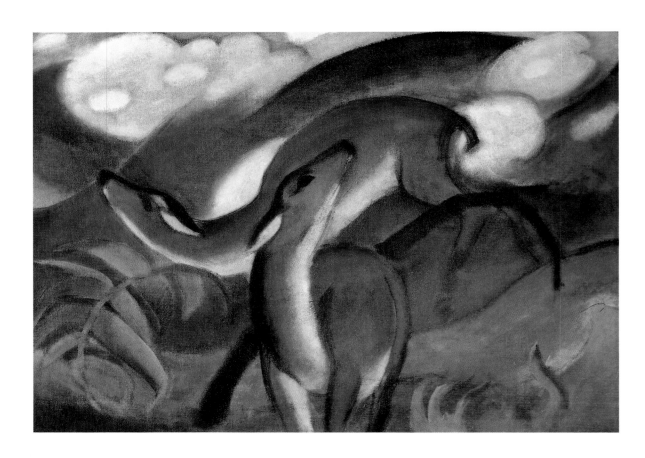

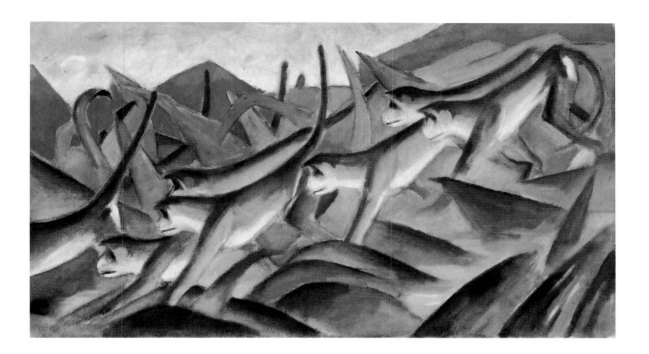

Monkey Frieze, 1911
Affenfries
Oil on canvas, 76 x 134.5 cm
Hamburg, Hamburger Kunsthalle

found sense of calm which issues from the standing horse. Absorbed in itself – it does not look out of the picture, but downwards –, it radiates self-assurance. Marc painted this picture when already an elected member of the New Artists' Association. He was at last having success with his paintings and felt himself strong enough to fight for the cause of modern art, as his response to the Vinnen Protest made clear. *Blue Horse I* can in this sense be seen as a form of self-portrait. In *The Yellow Cow* (p. 40), he uses "yellow, the female principle, gentle, cheerful and sensual" to express joie de vivre. In a considerably more concrete landscape rendered in hues of green, red, yellow and grey-black, a large, ponderous cow leaps across the picture, head luxuriously outstretched. The front legs taking her weight are braced against the ground, while her back legs are still in the air. This sense of momentum – giving the impression the animal will shortly vanish from the picture – stands in contrast to the calm landscape in which animals are peacefully grazing in the background.

In 1911 Franz Marc, like so many of his artist colleagues at the time, devoted himself to an intensive study of the art of non-European peoples. A letter to Macke proves that he made frequent visits to the Ethnological Museum in Berlin in January 1911. He must also have been familiar with illustrations from the increasing numbers of publications then appearing. In one case, the *Donkey Frieze* (p. 39), Marc's sources are known: an ancient Egyptian donkey frieze (p. 38) and animal masks from Cameroon. *The Yellow Cow* has also been linked with a Mycenaean

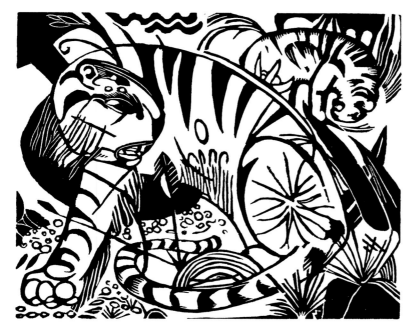

Tiger, 1912
Tiger
Woodcut, 20 x 24 cm

gold beaker decorated with bull-catching scenes – the beaker shows one animal in exactly the same leaping position. Marc did not, however, pursue his interest in primitivism to the same extent as the painters of the group Die Brücke, for example. It is even questionable whether the yellow of the cow can be traced to the gold of the beaker. The colour symbolism which Marc had developed for himself is here more likely to have played the decisive role.

His system of colour associations was not dogmatic, however, as demonstrated by his famous *Tiger* (p. 51) of 1912, in which yellow can be seen neither as female nor as gentle, cheerful or sensual. The soft, hilly landscape has here been replaced by sharp-edged, bizzare, angular shapes which, while they may point to a Cubist influence (as so often maintained), are determined above all by the nature of the subject. Amidst these green, violet, red and blue forms crouches the black-and-yellow tiger, ready to spring. His back is turned to the viewer and his head is twisted as he stares laterally out of the picture. The menace, strength of the animal and danger which can be read in his eyes are echoed in the incisive forms around him. Has Marc here truly expressed the feelings of the tiger, or has he instead imposed upon it human susceptibilities?

"..it feels it as a deer, and thus the landscape must also be 'deer'" wrote Marc in the winter of 1911/12. *Deer in the Woods II* (p. 36) of 1912 shows a small yellow deer lying in a sea of colour forms. A tree in the foreground cuts diagonally across the pictorial plane. The front part of the picture, in which the deer has curled up, feels calm and protective;

The Tower of Blue Horses, 1913
Der Turm der blauen Pferde
Oil on canvas, 200 x 130 cm
Missing

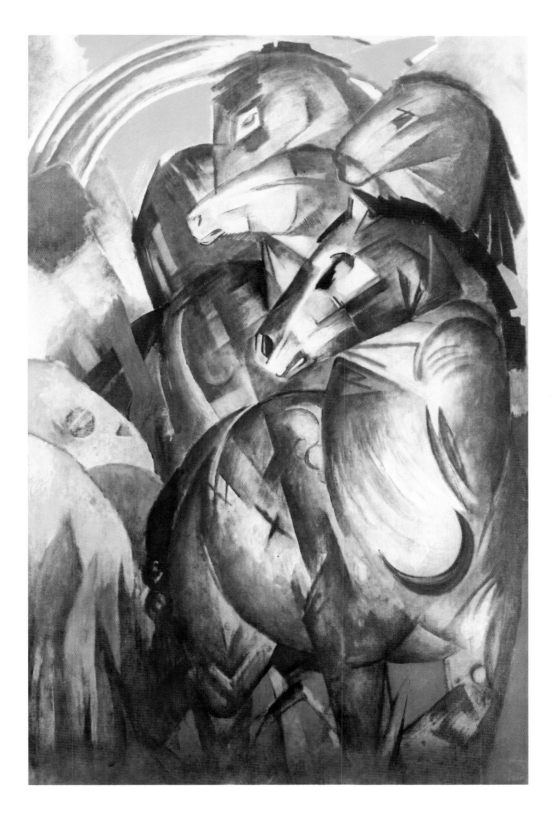

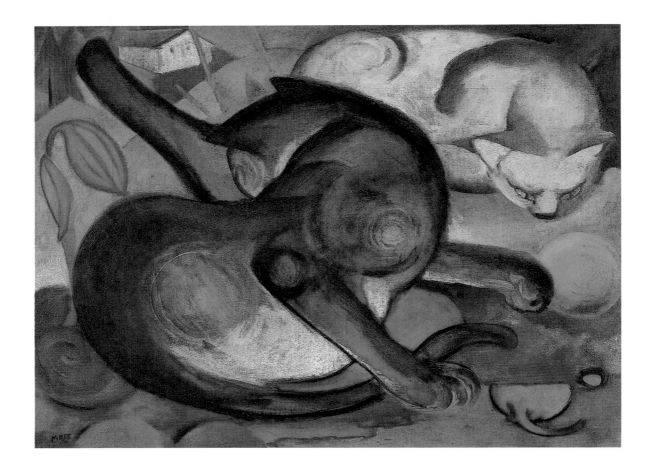

in the background, however, the forms take on motion and give the impression that a storm is passing through the forest. The viewer spontaneously transforms himself into the deer, which is sheltered and safe. The claim to feel as a deer does not hold; rather, the deer contains the man.

In his animal paintings Marc abandoned the objective viewpoint of the observer. He was not concerned with rendering the movements of animals just for the sake of it. In his attempt to imagine himself inside the animal, to see and to paint through its eyes, he painted human traits. "He raises them to his own level", as Paul Klee so rightly said.

This elevation of the animal, and in particular of the horse, is best seen in the famous *Tower of Blue Horses* (p. 45). Since this picture has been missing since 1945, we are today left only with reproductions which can no longer communicate the size and hence the actual impression which the original must have made on the viewer. Eye-witness accounts alone can bring alive the picture's impact: "A canvas 2 metres tall and 1.3 metres wide holds us spellbound. . . A group of four horses lights

Two Cats, Blue and Yellow, 1912
Zwei Katzen, blau und gelb
Oil on canvas, 74 x 98 cm
Basel, Öffentliche Kunstsammlung,
Kunstmuseum Basel

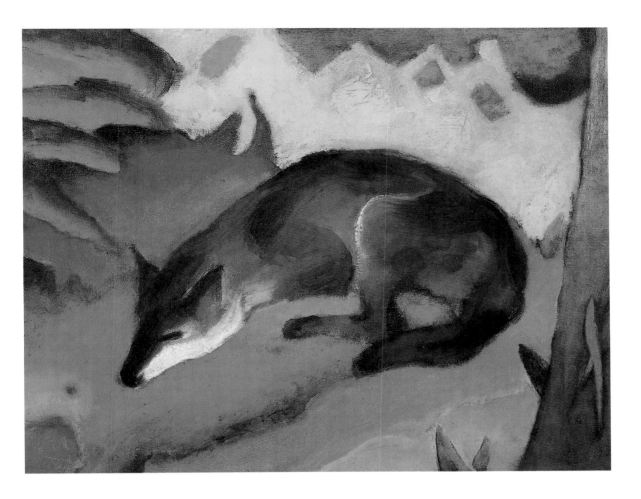

Blue-Black Fox, 1911
Blauschwarzer Fuchs
Oil on canvas, 50 x 63.5 cm
Wuppertal, Von der Heydt-Museum

up before our eyes like a vision. . . The mighty body of the foremost animal measures only a little less than life size. The horse seems to emerge from the depths and stop short directly in front of the viewer. . ."[15]

The four frontally-tiered animals are located to the right of the central axis. The powerfulness of their bodies is underlined by the fourfold repetition of the movement sequence. Their rumps forming the middle section of the composition, the horses stand angled to the right, but all have their heads turned to the left and thus into the picture, where a highly abstract rocky landscape projects into the pictorial space. An orange rainbow set against a yellow colour field concludes the top of the canvas. This rainbow, like the crescent moon on the breast of the first horse and the stars suggested by the crosses on its body, encourages the conjecture that Marc was here seeking to portray the unity of creature and cosmos. Man, who does not appear in this fusion of nature, animal and cosmos, is present in the sublimation of the horses. They demonstrate a power which is that of man. Here lies the fascination which this work exerts.

In many of the later pictures Marc's animals assume increasingly for-

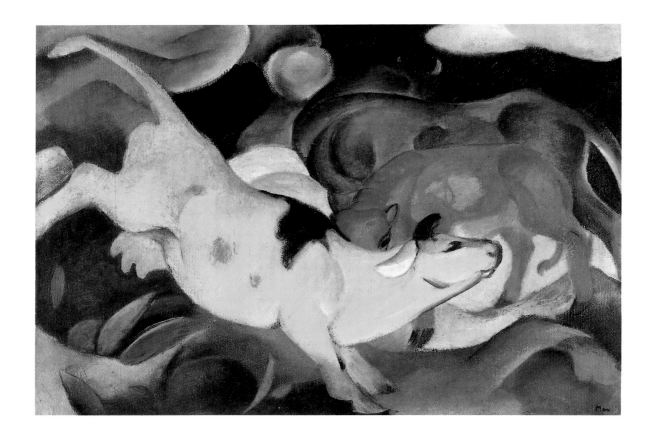

mularistic figures, something which will be discussed within the frame-work of stylistic development. The late painting *Birds* (p. 75) of 1914 is particularly significant with respect to the question of how far animals are depicted for their own sake. A number of birds are here seen emerging from coloured forms, which suggest beating wings. The whole painting seems to be flying. Attention has recently been drawn to a text which can be thematically linked to this picture, and which indicates the degree to which Marc worked his own ideas into his pictures and thereby projected himself into his animals. In "The New Painting", his programmatic essay of 1912 which provoked protest from Beckmann, he began with the following words: "The most noteworthy years in the development of modern art remain the 90's of the last century, when French Impressionism consumed itself in its own fire while a flight of new ideas arose, phoenix-like, from its ashes, birds with colourful feathers and mystical beaks."[16] The departure for new shores of which Marc here speaks can be seen symbolized in this painting, in particular in the birds in flight in the centre and in its upwardly-straining forms.

Cows, Yellow-Red-Green, 1912
Kühe, gelb-rot-grün
Oil on canvas, 62 x 87.5 cm
Munich, Städtische Galerie im Lenbachhaus

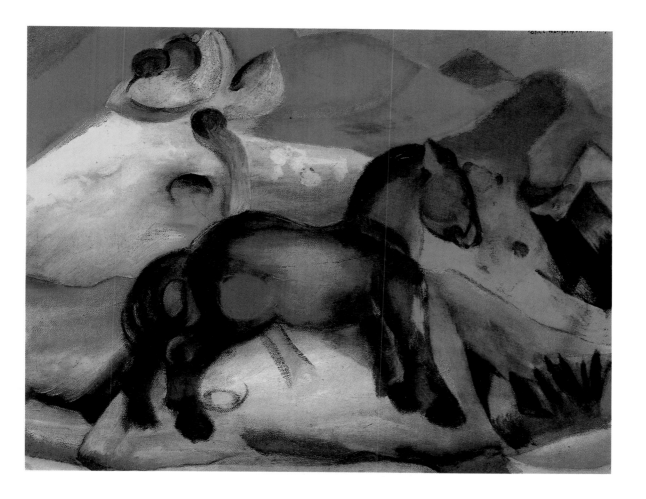

The Little Blue Horse, 1912
Das kleine blaue Pferdchen
Oil on canvas, 57.5 x 73 cm
Saarbrücken, Saarland-Museum

In 1914 Marc also began to paint non-representational pictures. The animal had now lost the significance it had previously held for him. In the letter to Maria Marc of 12 April 1915 quoted earlier, which may be seen as a summary of his artistic achievements, he wrote: "Another instinct led me away from animals towards abstraction, which excited me even more; . . .I found people 'ugly' very early on; animals seemed to me more beautiful, more pure; but even in animals I discovered much that was unfeeling and ugly, so that my pictures instinctively. . . became increasingly more schematic, more abstract."[17]

Marc now no longer employed the animal as a means of portraying himself and his feelings, his inner sensitivity. He distanced himself ever further from the object, until his first abstract works were born. At this point his development came to a halt.

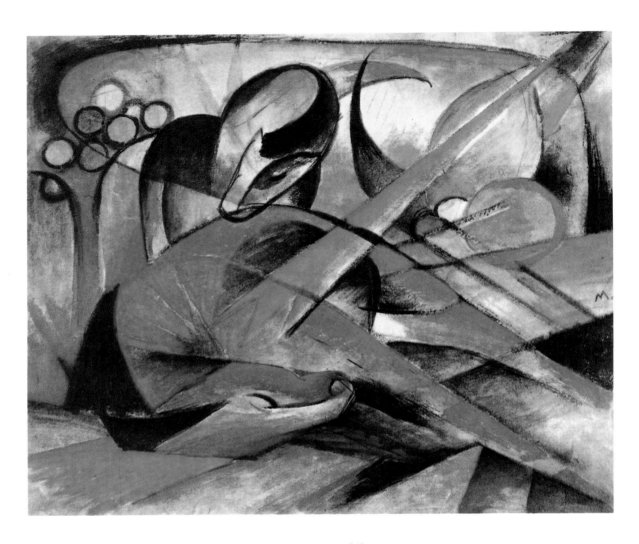

Dreaming Horse, 1913
Träumendes Pferd
Watercolour on paper, 39.4 x 46.3 cm
New York, Solomon R. Guggenheim Museum

Tiger, 1912
Tiger
Oil on canvas, 111 x 111.5 cm
Munich, Städtische Galerie im Lenbachhaus

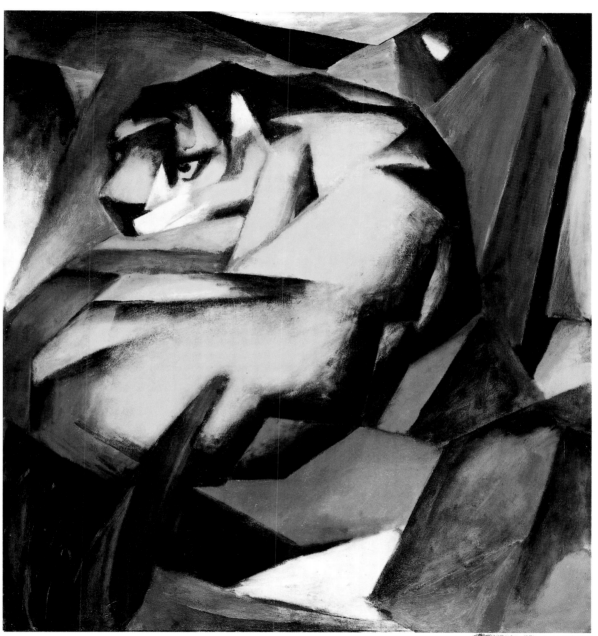

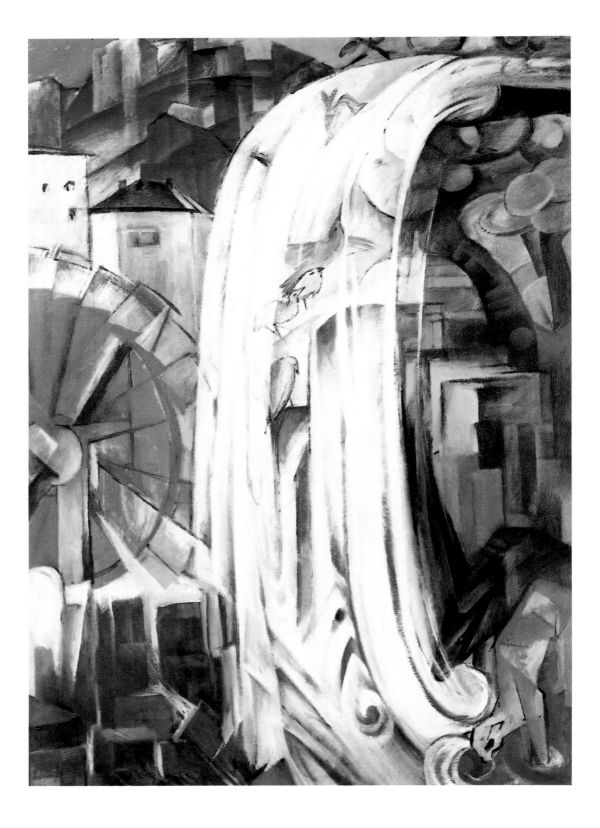

From the Blaue Reiter to the First German Autumn Salon

Franz Marc and the Blaue Reiter are inseparable. There are numerous publications devoted to the history of the Blaue Reiter; here we shall only be examining Marc's role within the group, since it was to leave a decisive stamp upon his subsequent dealings and works.

Der Blaue Reiter (The Blue Rider) is a name which today conjures up a group of artists in Schwabing, Munich, headed by Wassily Kandinsky and Franz Marc. Originally, however, it meant something rather different. After completing the manuscript of "Concerning the Spiritual in Art", Kandinsky planned the publication of a form of almanac whose pages would be filled by contributions solely from artists – albeit not solely from fine artists. He did not feel capable of realizing this idea singlehandedly, however.

"Then Franz Marc arrived from Sindelsdorf. One conversation sufficed; we understood each other perfectly." The co-operation between the two artists did not begin quite as straightforwardly as Kandinsky subsequently recalled in 1930. It is more likely that Kandinsky's goodwill towards his comparatively young colleague had been fostered by the protest which they had each – independently – planned against Vinnen's militant paper and which they were subsequently able to launch together. This undertaking introduced Kandinsky to the talents of his new-found friend in the publishing field. He and Marc furthermore shared similar views on painting, as had already emerged from Marc's enthusiastic review of the second New Artists' Association exhibition, in which he had employed the word "spiritual" in a similar sense to Kandinsky.

The publishing of a journal had long been one of Marc's own dreams. He did not share the view that artists should be "seen and not heard"; instead, he wanted to elucidate the pictures he was painting, the art he and his friends were creating, by means of presentation and the written word.

On 19 June 1911, in a letter to Marc which has since passed into legend, Kandinsky suggested to his younger friend that they should jointly publish a kind of almanac. It would compare and contrast pictures from different cultural groups and include writings by artists. No answering letter from Marc has survived; since he frequently met Kandinsky in person, it is indeed questionable whether he ever gave a written reply.

Work on the almanac began very soon after Kandinsky's letter. Marc

Sleeping Shepherdess, 1912
Schlafende Hirtin
Woodcut, 19.8 x 24.1 cm

The Enchanted Mill, 1913
Die verzauberte Mühle
Oil on canvas, 130.6, x 90.8 cm
Chicago, The Art Institute of Chicago

The Little Blue Horses, 1911
Die kleinen blauen Pferde
Oil on canvas, 61 x 101 cm
Stuttgart, Staatsgalerie,
Lütze collection

". . .what on earth will people think of me
when they see (my pictures)! It worries me
that not one of them is clear enough to allow
my wish to be read unambiguously, my wish
for a religion which isn't there; but you
can't pack up painting just because you've
arrived on this planet 50 or 100 years too
early. If only you could put your head under
a blanket for 100 years and then start all
over again." Franz Marc, 31. 7. 1912

confided their plans to August Macke in September and asked for his
help. He arrived in October and clearly enjoyed the busy atmosphere pre-
vailing in Sindelsdorf and Murnau, where meetings were held alternate-
ly. The name was agreed on in September. In his memoirs, Kandinsky
wrote simply: "We invented the name 'The Blue Rider' in the garden in
Sindelsdorf. We both loved blue, Marc horses and I riders. The name
thus arose of its own accord."[18]

During work on the almanac, tensions within the New Artists' Asso-
ciation were growing. Indeed, the memorable meeting at which Marc
and Kandinsky announced their resignation took place before the alma-
nac had finally appeared through Piper. Within a fortnight they had suc-
ceeded in organizing another exhibition, separate from that of the New
Artists' Association, in the adjoining rooms at Thannhauser's gallery. It
contained 50 works by a total of 14 artists and aimed, like the almanac,
to juxtapose very different trends in modern painting on an international
basis.

Over the next few years, this exhibition – which included paintings
by Albert Bloch, David and Vladimir Burliuk, Heinrich Campendonk,
Robert Delaunay, Elisabeth Epstein, Eugen von Kahler, Wassily Kandin-
sky, August Macke, Franz Marc, Gabriele Münter, Jean Bloé Niestlé,
Henri Rousseau and the composer Arnold Schoenberg – travelled to Co-
logne, Berlin, Bremen, Hagen, Frankfurt, Hamburg, Rotterdam, Amster-
dam, Barmen, Vienna, Prague, Budapest, Königsberg, Oslo, Lund, Hel-

singfors, Stockholm, Trondheim and Göteborg. In Berlin it was shown in Herwarth Walden's newly-opened gallery "Der Sturm". It was Walden, too, who helped organize the Scandinavian venues.

The exhibition was also called Der Blaue Reiter by its two "makers". Not long afterwards they exhibited prints and watercolours at Goltz's art gallery. In this second and last exhibition by the "Editors of Der Blaue Reiter", the French were represented in much greater strength; alongside Robert Delaunay were works by Georges Braque, Roger de la Fresnaye, André Derain, Pablo Picasso, Robert Lotrion and Maurice Vlaminck.

In Berlin at Christmas 1911, Marc had met a group of artists previously entirely unknown in Munich, who called themselves Die Brücke. Marc subsequently took prints by Erich Heckel, Ernst Ludwig Kirchner, Otto Mueller and Max Pechstein back with him for the exhibition. It was the first contact between the two major Expressionist currents in Germany, currents which are frequently described as rivals although they themselves never viewed each other as such.

Paul Klee was also represented alongside other German and Swiss artists. Through the agencies of Kandinsky, the Russians Natalia Goncharova, Mikhail Larionov and Kasimir Malevich also sent works for the show. The internationality which these exhibitions thus manifested, and which stood in such stark contrast to the nationalistic tendencies as revealed by the Vinnen Protest, for example, remains remarkable and significant today. The first exhibition by the editors of the Blaue Reiter is today viewed as the birth of Modernism in Germany.

After many difficulties and disagreements with Reinhard Piper, naturally again acting as publisher, and after repeated alterations to the list of contents as a consequence of contributions running counter to editorial ideas or being submitted too late, May 1912 finally saw the publication of the almanac that wasn't. Shortly before going to press Piper had insisted this word be dropped from the title. Kandinsky had subsequently removed it from his woodcut. Even the two editors were no longer talking of an annual organ but of a series to appear in irregular sequence. But their plans remained unrealized: Der Blaue Reiter was to get no further than the first volume.

One hundred and forty illustrations were accompanied by nineteen articles. Ethnological objects, medieval works of art and folk art and in particular Bavarian glass paintings were shown along with pictures of modern art. For Marc and Kandinsky, the parallels lay in the immediacy with which all these works of art had been created.

The publication opened with three short texts by Marc and concluded with three longer ones by Kandinsky. Sandwiched inbetween were contributions from fine artists such as August Macke and David Burliuk and musicians such as Arnold Schoenberg and the Russian Thomas von Hartmann.

The Blaue Reiter almanac – as it is still known today for the sake of simplicity – was not an overview of a mature movement or a systematic summary of the art theories of the times. Rather, it appeared at the beginning of a development which was to end only in 1914, namely the devel-

opment of painting towards abstraction. The almanac can be seen as a programme of modern aesthetics which addresses, however incompletely, the principles of artistic creation.

In his essay "On the Question of Form", Kandinsky sought to further specify the concept of "inner necessity" which he had already introduced in "Concerning the Spiritual in Art". Here – and not, as often incorrectly assumed, in the earlier essay – he introduced the concepts of "the great abstraction" and "the great realism" still valid today. In his important work on the "Grundlagen der modernen Kunst" (Principles of Modern Art), Werner Hofmann has shown that Kandinsky's essay, and above all his two concepts, are of decisive importance for artists right up to the present. Marc may not today count as a founding father of modern art, but Kandinsky nevertheless conferred this rank upon him: "The strong abstract sound of physical form does not necessarily demand the destruction of the representational. In the painting by Marc *(The Bull)* we can see that here, too, there are no general rules. The object can thus fully retain both inner and outer sound, and its individual parts may be transformed into independently sounding abstract forms and thereby create a general abstract overall sound."[19]

In his own short articles for the Blaue Reiter almanac, Franz Marc himself evolved theses which have lost none of their relevance today.

In his first text, "Spiritual Treasures", he observed that mankind delighted in new colonial conquests and new technical advances but never in new spiritual treasures, whereby he meant new art in particular. He regretted "people's general lack of interest in new spiritual treasures" and, in conclusion, formulated the sentence still applicable today: "New ideas are hard to understand only because they are unfamiliar. . .".

Reconciliation, 1912
Versöhnung
For the poem of the same title by
Else Lasker-Schüler
Woodcut, 20 x 25.8 cm

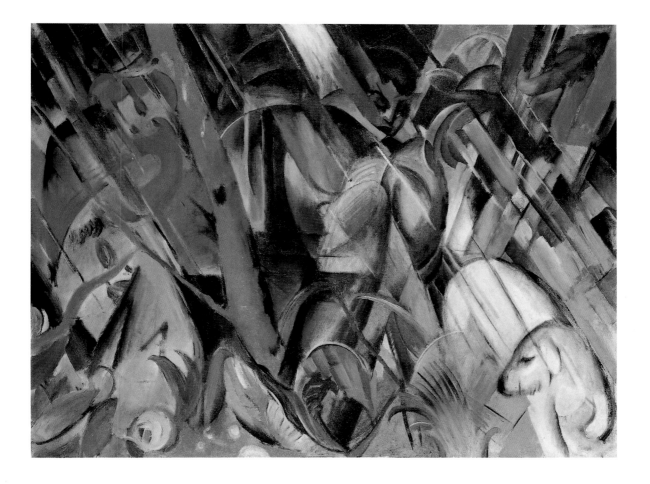

In the Rain, 1912
Im Regen
Oil on canvas, 81.5 x 106 cm
Munich, Städtische Galerie im
Lenbachhaus

His second text addressed "The 'Savages' of Germany". These
would fight against an "old, established power" which might be superior
in number but which would be conquered by the "power of ideas".
These "Savages" included the Brücke artists, the Neue Sezession in Ber-
lin and the New Artists' Association (this text was clearly written before
Marc's resignation). Following a brief description of the history of these
three groups, he defended them against the repeated claim that their art
had developed out of Impressionism. He declared the aim of the "Sav-
ages" in the following oft-quoted, today highly pompous-sounding
words: "To create from their work symbols for their age, symbols which
belong on the altars of a future spiritual religion, symbols behind which
their technical heritage cannot be seen."[20] Without naming names, he ac-
cused some of the "Savages" of superficiality. It is clear that he had the
remaining members of the New Artists' Association in mind.

In his third article, "Two Pictures", he proposed that the world was
currently experiencing a period of upheaval similar to that of the era of
Christianization. At that time an entirely new art had arisen which had
also first needed to be understood. He then compared a 19th-century il-

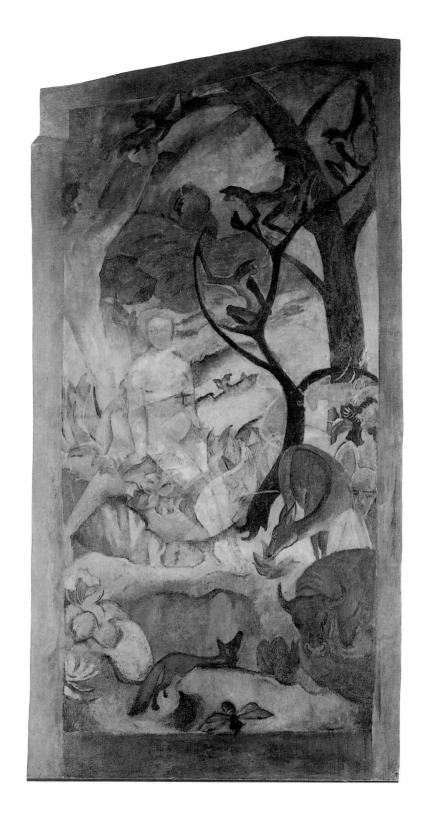

lustration of a fairy tale with a picture by Kandinsky and argued that both were inspired by the same depth of feeling. But while everyone in the 19th century had been able to understand the fairy-tale picture, the situation today was different. Contemporary art was being created without a link to its public – "rather, in defiance of its times". Such pictures "are wilful, fiery signs of a new age which are today multiplying everywhere. This book is to be their focus until the dawn arrives, and with its natural light removes from these works the spectral shape in which they appear to the present world. What today appears spectral will tomorrow be natural."[21]

The Blaue Reiter almanac sold so well – 1200 copies had been printed – that in 1914 a new edition was necessary. Sales did not cover costs, however, since the book was priced far too low. This in turn arose from unclear agreements between the editors and the publisher. It was Bernhard Koehler who finally came to the rescue since, according to the contract with Piper, Marc and Kandinsky were liable for the covering of costs.

Plans for a second volume were being made even as the first was under completion. But work on the project was repeatedly delayed. So as not to be distracted from painting altogether, Marc and Kandinsky decided to take editorial responsibility for each issue in turn. Marc took over the second volume. There were nevertheless consultations between the two artists. In March 1914, the new introductions for the second edition having just been finished, Kandinsky wrote to Marc that he would have to withdraw fully from the project for a while – it was preoccupying him to such an extent that he was unable to think of anything else and his painting was suffering. Marc was disappointed, but respected his friend's decision. The two introductions, revised after Kandinsky's announcement, also reflect the artists' moods: new ideas are pursued resignedly by Kandinsky and optimistically by Marc. It was clear from the introductions that a new volume would not be appearing quite so soon after all. Marc nevertheless planned to publish something single-handedly. Whether he would have realized this intention had not war destroyed all his plans must remain a matter for speculation. But in view of the many other occasions upon which, in the period between the appearance of the Blaue Reiter almanac and the outbreak of war, he took up the cause of modern art, it seems it would not have been beyond his capacities.

In March 1912, for example, he wrote the article on "The New Painting" for "Pan" magazine which was quoted above in connection with his 1914 painting, *Birds*. Here he sought to demonstrate that the art he called "new" had its antecedents not in Impressionism, but at most – and even then only to a limited degree – in Cézanne. More important than the question of antecedents was, he believed, the question of what modern art was seeking to achieve: "We are today seeking the things in nature hidden behind the veil of appearances. . . We seek and paint this inner, spiritual side of nature. . .because this is the side we see, just as in earlier times people suddenly 'saw' violet shadows and the ether in which all

Paradise, 1912
Paradies
with August Macke
Oil on plaster, 400 x 200 cm
Münster, Westfälisches Landesmuseum für Kunst und Kulturgeschichte

PAGE 60/61:
Deer in the Monastery Garden, 1912
Reh im Klostergarten
Oil on canvas, 75.7 x 101 cm
Munich, Städtische Galerie im Lenbachhaus

Sketch of Brenner Road, 1913
Skizze von der Brennerstraße
Pencil and watercolour, 20 x 12.3 cm
Munich, Galerie Stangl

things were bathed. It is no more possible to explain their vision than ours. It lies in the times."[22] This last sentence was of central significance for Marc. From here he went on to argue that new painting was "no Parisian phenomenon" but "a European movement". He stated categorically: "Every age has its quality", and demanded an objective discussion "on the artistic worth or unworth of the new pictorial ideas".

The next issue carried an extremely polemical reply by Max Beckmann, who just one year earlier had reacted to the Protest by German Artists together with Marc in "The Battle for Art". There too, however, Beckmann had argued from a different angle. He held "artistic sensitivity combined with the artistic objectivity of the things to be represented" to be the most important thing in art. His definition of artistic quality contradicted that of Marc. For Beckmann, quality meant a feeling "for the peach-coloured shimmer of a skin, for the glossiness of a nail. . .the glaze of oils. . ..". He polemicized against "framed Gauguin wallpaper, Matisse materials, Picasso chessboards and Siberian-Bavarian memorial tablets" and concluded with the words: "The laws of art are eternal and unchanging, like the moral law within us."[23]

Marc felt himself obliged to reply, although he emphasized that it was not really possible to answer such a response since it did not "invite in-depth discussion". He polemicized back and once again underlined his definition of quality: "quality means the inner greatness of a work, by which it is distinguished from works by imitators and lesser minds."[24]

Two trends of modern art here met head on. Beckmann himself could hardly be described as "anti-progressive". The two schools have recently been captioned "objectivity" and "inner sound". This is not the place to judge. It is a fact, however, that both standpoints have survived until today – and that both continue to do battle with similar arguments. Beckmann was thereby able to establish himself as a "spokesman", a father of representational art. Marc, on the other hand, is rarely viewed by contemporary abstract artists as one of their own kind. His popularity as a painter of blue horses overshadows his theoretical statements on art and his paths to abstraction. But to belittle these latter is to do serious injustice to Kandinsky's travelling companion.

Marc's painting was displaying tendencies towards abstraction in as early as 1912, the year in which the Blaue Reiter almanac was published and Beckmann and Marc were arguing their controversial viewpoints. While the majority – and the most famous – of his pictures continued to show animals such as tigers, cows and horses, *Deer in the Monastery Garden* (pp. 60/61) is dominated by abstract, in part bizarre forms creating almost no impression of spatial depth. The deer – still the centre of the painting – consists only of back and head. Everything else is hidden, seems unnecessary. Only through the little we see of the deer can the remaining forms be deciphered as trees, sun and buildings. As soon as something familiar appears in a picture, we group everything else around it. It is questionable, however, whether Marc intended these associations. In his choice of title, he undoubtedly – if perhaps unconsciously – encourages the viewer to identify architecture and plants in his painting.

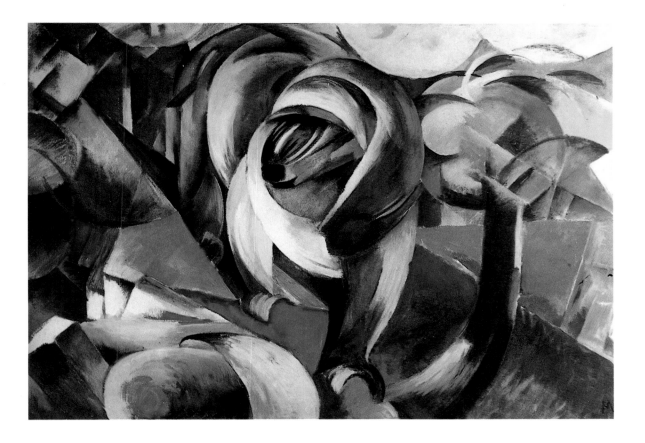

On the other hand, however, he saw abstraction as a challenge. This emerges from the "Theses on Abstract Art" which he put down on paper in 1912/13. As for Kandinsky, idea and will existed before they could be translated into deed.

A trip taken in October 1912 was decisively important for this development towards abstraction and indeed towards such paintings as *Deer in the Monastery Garden* and *In the Rain* (p. 57). Franz and Maria Marc visited the Mackes in Bonn in order to at last view the Sonderbund exhibition in Cologne. In the summer, shortly before the start of the exhibition, the rejection by the jury of numerous pictures by the group gathered around the editors of the Blaue Reiter, which meanwhile included Alexei von Jawlensky and Marianne von Werefkin, had precipitated a serious row between Marc and Macke, since Macke had been involved in organizing the exhibition. The Marcs had consequently not attended the opening. Now, however, Marc was deeply impressed by a number of paintings. He wrote enthusiastically to Kandinsky of works by Munch, Heckel, Picasso and above all Matisse. "I don't like my own things at all; they're sweet and sickly. I'm horrified". On the spur of the moment the friends decided to go to Paris, where they met, among

The Mandrill, 1913
Der Mandrill
Oil on canvas, 91 x 131 cm
Munich, Staatsgalerie moderner Kunst

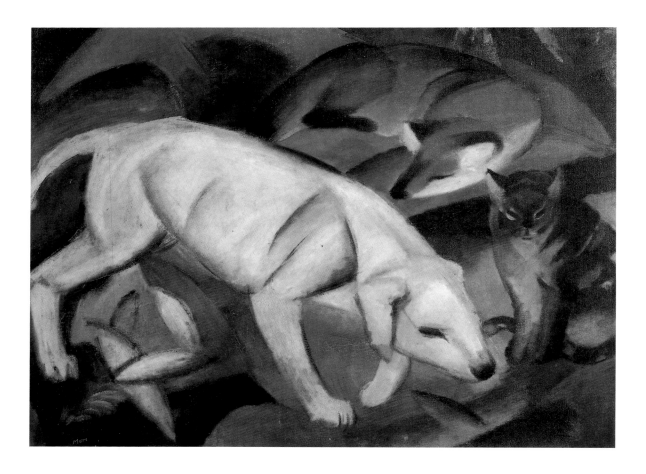

Three Animals (Dog, Fox and Cat), 1912
Drei Tiere (Hund, Fuchs und Katze)
Oil on canvas, 80 x 105 cm
Mannheim, Städtische Kunsthalle

Wild Pigs (Boar and Sow), 1913
Wildschweine (Eber und Sau)
Oil on cardboard, 73 x 57.5 cm
Cologne, Wallraf-Richartz Museum

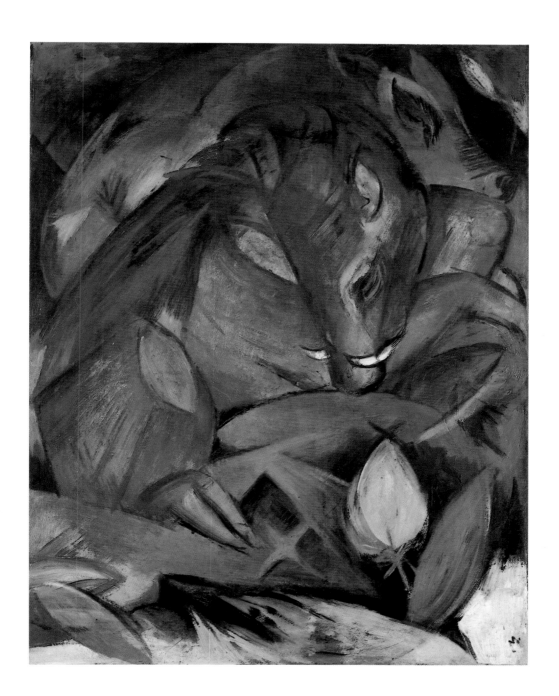

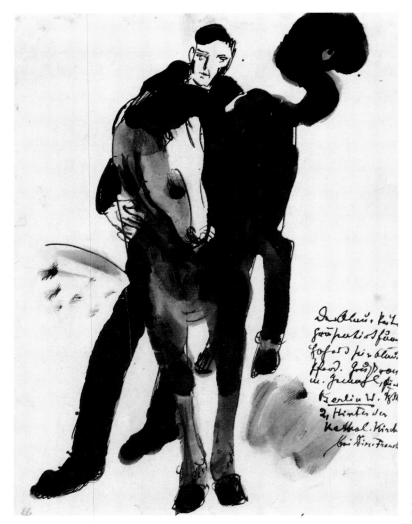

The Blue Rider and His Horse, 1912
Der blaue Reiter und sein Pferd
Ink and Indian ink, 15.4 x 11.4 cm
Munich, Bayerische Staatsgemälde-
sammlungen

others, Delaunay. Robert Delaunay (1885–1941) had been strongly in-
fluenced by Cubism. He gradually found his independence by assigning
increasing significance to colour – a development which did not fit into
Cubist thinking. He began to devote intensive study to the relationships
of complementary colours and to simultaneous contrasts. Simultaneous
contrasts arise due to the fact that the eye, seeing one colour, demands to
see its complementary colour and, where this is not present, creates it it-
self. These studies ended with Delaunay giving colour pride of place: for
him, colour became the "object" of the picture, which in 1912 led to
"pure painting", complete freedom from the object. This art movement –
which was also seeking parallels with the laws of music – was named Or-
phism by the poet Guillaume Apollinaire.

Remembering the letters of 1910/11 in which Marc and Macke discussed problems of colour, it is understandable that they should have been impressed by Delaunay's pictures. Macke and Delaunay established numerous similarities in their theoretical thinking which were subsequently reaffirmed in talks held when the Frenchman visited Bonn. Marc and Delaunay had less in common, however; Delaunay's influence was limited to the adoption by Marc of certain of his stylistic means and was not, as it had been for Macke, a revelation.

Back in Bonn, Marc was invited to help hang an exhibition of Italian Futurists being held in the Gereonsklub in Cologne. He had previously seen only the catalogue of their exhibition held that spring in Walden's Berlin gallery "Der Sturm", where the writings of the Italians had already impressed him deeply. He was now enthralled by their works. The Futurists sought to capture light, illumination and atmosphere in their paintings and furthermore to render movement, speed, simultaneity and penetration.

Marc's later pictures reflect the processing of both the painting of Delaunay and the principles of the Futurists, but without losing sight of "his" subject, the animal.

Quite apart from the impressions left by the Bonn visit, Marc was here at last able to fulfil a wish he had expressed to Macke at the start of their friendship. The two friends now together decorated one wall of Macke's studio with a subject from the Garden of Eden (p. 58). They did not choose the Fall for their large-format mural, however, but instead Paradise in its original state. The artistic distance between them was not yet so great as to make such a joint undertaking impossible.

The Marcs again spent Christmas in Berlin with Maria's parents. There they met the poetess Else Lasker-Schüler, with whom they soon become close friends. Marc had already sent her a hand-painted postcard from Munich giving her his address in Berlin. Alongside a horse and a man (Franz Marc) appear the words: "Der blaue Reiter präsentiert Eurer Hoheit sein blaues Pferd. . ." ("The blue rider presents Your Highness his blue horse. . .") (p. 66). This was to be the first of 28 postcards which the artist wrote to the poetess over the next few years (pp. 68/69). They were answered with long letters which Else Lasker-Schüler also illustrated with drawings. These letters later formed the basis for her novel *Malik*. Their correspondence documents the mutually complementary relationship between Expressionist poetry and painting. Not until 1987 was this material published and annotated in its entirety.[25] It should be noted that Marc's 1913 New Year greetings to Lasker-Schüler simultaneously represented the first colour draft of *The Tower of Blue Horses*. The crescent moon and stars decorating the horses were the personal insignia of the poetess. Marc referred in this picture both to her and her favourite colour, blue. He incorporated these details into his large painting of the same name (p. 45), which thus owes much to the encounter with the poetess.

The year 1913 was also dominated by cultural politics and artistic developments. In January the Thannhauser gallery staged a large exhibition

ILLUSTRATIONS PAGE 68:

The Tower of Blue Horses, 1912/13
Der Turm der blauen Pferde
Ink, gouache, 14.3 x 9.4 cm
Munich, Bayerische Staatsgemälde-sammlungen

King Jussuf's Three Panthers, 1913
Die drei Panther des Königs Jussuf
Ink, watercolour, gouache, 13.8 x 9 cm
Munich, Bayerische Staatsgemälde-sammlungen

Prince Jussuf's Lemon Horse and Fire Ox, 1913
Zitronenpferd und Feuerochse des Prinzen Jussuf
Ink, watercolour, gouache, 14 x 9.1 cm
Munich, Bayerische Staatsgemälde-sammlungen

King Abigail's Pet Horse, 1913
Das Spielpferd des Königs Abigail
Ink, watercolour, gouache, 13.9 x 9 cm
Munich, Bayerische Staatsgemälde-sammlungen

ILLUSTRATIONS PAGE 69:

The Dam of the Blue Horses, 1913
Die Mutterstute der blauen Pferde
Ink, gouache, 14 x 9 cm
Munich, Bayerische Staatsgemälde-sammlungen

The Holy Calf, 1913
Das heilige Kälbchen
Gouache, ink, 14 x 9 cm
Munich, Bayerische Staatsgemälde-sammlungen

Horse, 1914
Pferd
Ink, watercolour, gouache, 14.9 x 9.9 cm
Munich, Bayerische Staatsgemälde-sammlungen

The Dream Rock, 1913
Der Traumfelsen
Ink, watercolour, gouache, 14.2 x 8.9 cm
Munich, Bayerische Staatsgemälde-sammlungen

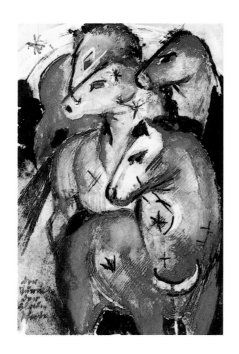

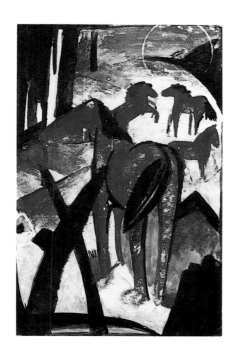

Diese heilige Stündchen wird am
Tage der Wiederbesteigung des
bösigt stülstin ... Garten des Pulochots
Offenland gefunden.

Liebes Jastütsch, wir Hüre sün
dim durste!! Hürendspäes!!
Prosit – Neujahr!

Der Tränenhölgen

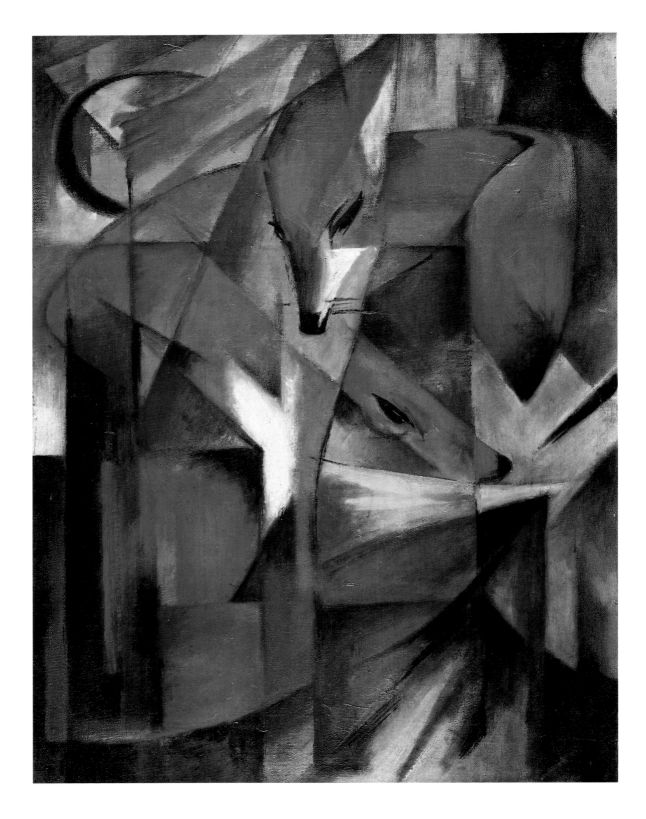

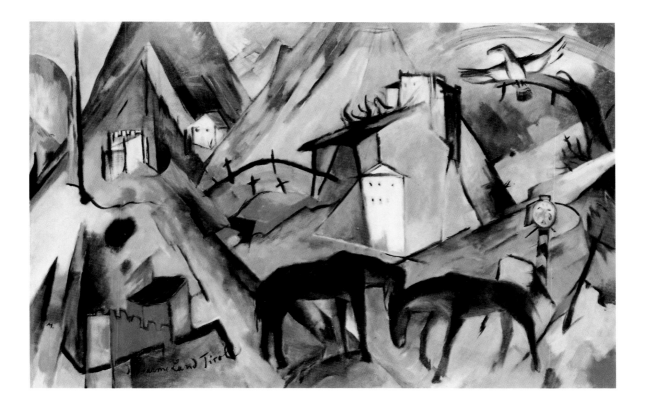

of the exhibition and the selection of the artists. Klee, Delaunay and others were consulted for advice. They were in particular requested to find suitable artists of their own nationalities, in this case Swiss and French.

Ninety artists from France, Germany, Russia, Holland, Italy, Austria, Switzerland and the USA contested the First German Autumn Salon with a total of 366 works. A particularly large amount of space was reserved for Robert Delaunay and his wife Sonia Delaunay, co-organizers Marc, Macke and Kandinsky, Blaue Reiter artists such as Heinrich Campendonk, Gabriele Münter, Paul Klee and Alfred Kubin, and the Italian Futurists.

In retrospect, the Autumn Salon was one of the most important exhibitions of modern art to be held before the First World War. Walden's claim to represent the German avant-garde was fully justified. The exhibition was nevertheless slated by the press of its day. Financially, too, the Autumn Salon proved a disaster. Bernhard Koehler, who had guaranteed an indemnity of 4000 Marks, had to increase this to 20,000 Marks at the end of the exhibition. Marc showed seven new paintings, including *The Tower of Blue Horses, Animal Destinies, Tyrol, The First Animals* and *The Wolves* (Balkan War). He had named these and other pictures – such as *The Poor Land of Tyrol* and *The World Cow* - in a letter to Macke back in May, writing that they were all very different pictures

The Poor Land of Tyrol, 1913
Das arme Land Tirol
Oil on canvas, 131.5 x 200 cm
New York, Solomon R. Guggenheim Museum

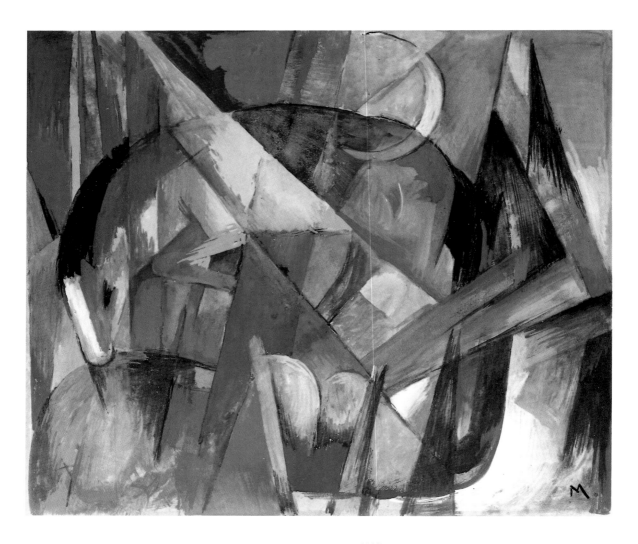

Fabulous Beast II (Horse), 1913
Fabeltier II (Pferd)
Tempera on cardboard, 26.5 x 30.5 cm
Private collection

Birds, 1914
Vögel
Oil on canvas, 109.5 x 99.5 cm
Munich, Städtische Galerie im Lenbachhaus

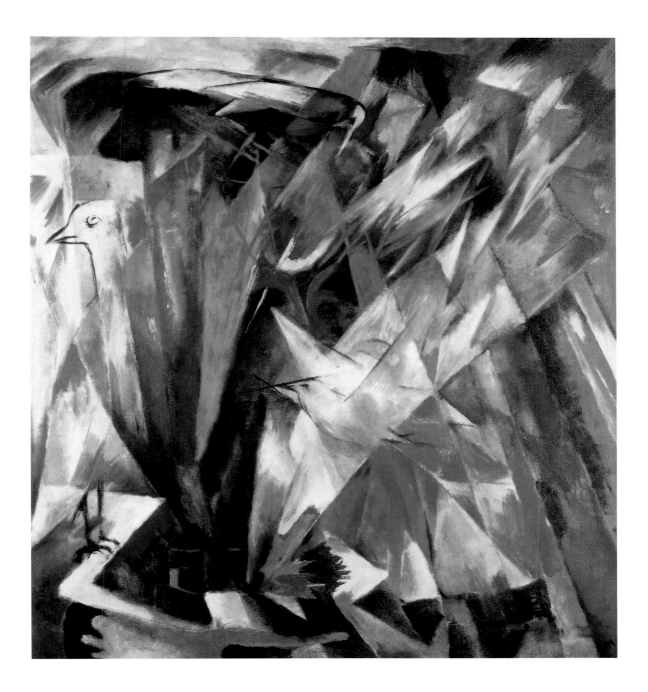

which he had only just completed. This description certainly fitted the facts.

In the painting *The Poor Land of Tyrol* (p. 73), which Marc followed shortly afterwards with one entitled *Tyrol* (p. 77), he reproduced the impressions left by a trip to South Tyrol with Maria Marc in March 1913. Marc sprinkles houses, gravestones and a few animals between towering mountains. Colouring aside, he here works with astonishingly realistic set pieces which almost appear as a retraction of statements made a year earlier in paintings such as *Deer in the Monastery Garden* (pp. 60/61). In contrast, *The Tower of Blue Horses* (p. 45) appears considerably more abstract. The bodies of the horses are composed of individual geometric parts, while the "landscape" consists of no more than abstract formations. This abstraction is carried to its extreme in *Animal Destinies* (p. 71). Horses, pigs, wolves and a deer only emerge with effort from the pointed, threatening forms. The relative calm prevailing in the two previous-named paintings has here given way to an immense dynamism which has gripped both forms and animals. Nature seems to be convulsed within a self-destructive force.

Marc originally entitled the picture *The Trees Show their Rings, the Animals their Veins,* and noted on the back of the canvas: "And all being is flaming suffering". It was Klee who suggested "Animal Destinies" in response to the request for help with a suitable name. As in the case of *The Tower of Blue Horses,* much speculation surrounds this picture. Marc himself, having received a postcard reproduction of *Animal Destinies* from Koehler, wrote to Maria in 1915: "It is like a premonition of this war, horrible and gripping; I can hardly believe I painted it! But in the blurred photograph it appears incomprehensibly real, giving me a most uncanny feeling."[26]

It seemed obvious to credit Marc with prophetic powers. According to one interpretation from 1956, four different behavioural reactions to the onset of a catastrophe can be identified in the picture. More probable is the argument that Marc here stages his own, very personal Apocalypse. He had to sacrifice his animals in order to free himself from them, in order to be able to move on to the non-representational image. The contemporaneity of pictures such as *The Tower of Blue Horses* and *Animal Destinies* thereby strikes a strange chord. They are the expression of an ambivalence which was to intensify in 1914 and which can be found both in Marc's representational and so-called abstract works.

Marc always held fast to the significance of the object in a painting, although he defended the abstract work of Kandinsky and Delaunay and produced his own first abstract painting in 1913. He summarized his beliefs in a letter to Walden written in the run-up to the Autumn Salon. Walden had apparently declared the "representational" in art to be irrelevant. Marc's reaction was vehement: "Whether you paint the Virgin Mary in majesty or asparagus does not decide the quality of a picture or its value – but it can make one *hell of a difference*. . ."[27] This "difference" can be sensed above all in the works of Marc's final years.

Tyrol, 1914
Tirol
Oil on canvas, 135.7 x 144.5 cm
Munich, Staatsgalerie moderner Kunst

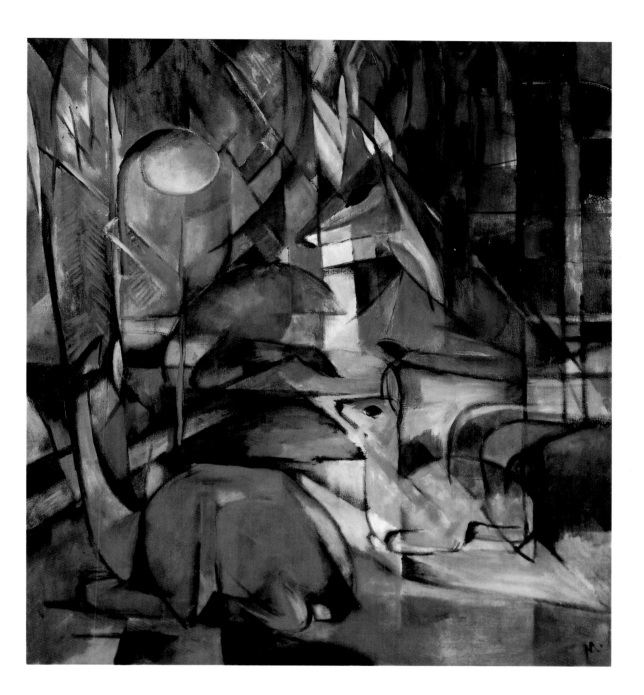

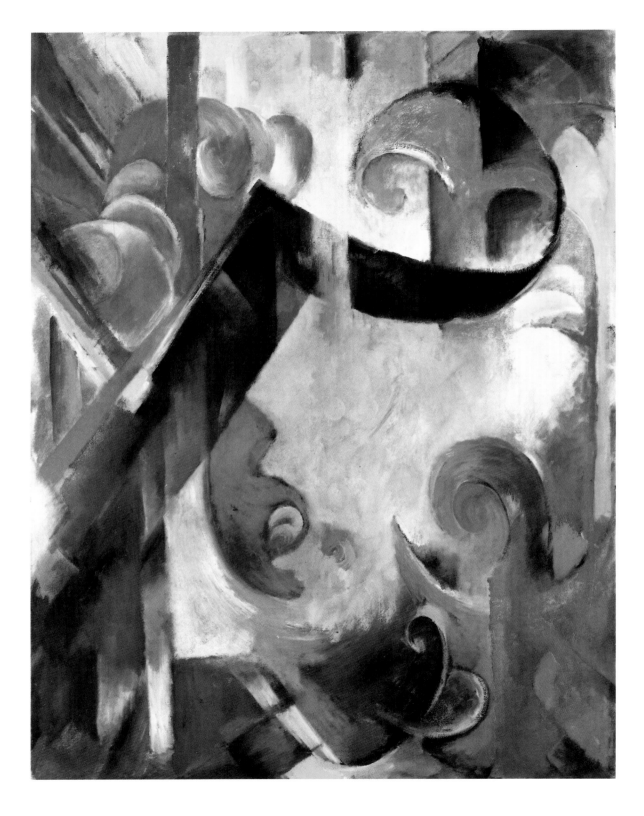

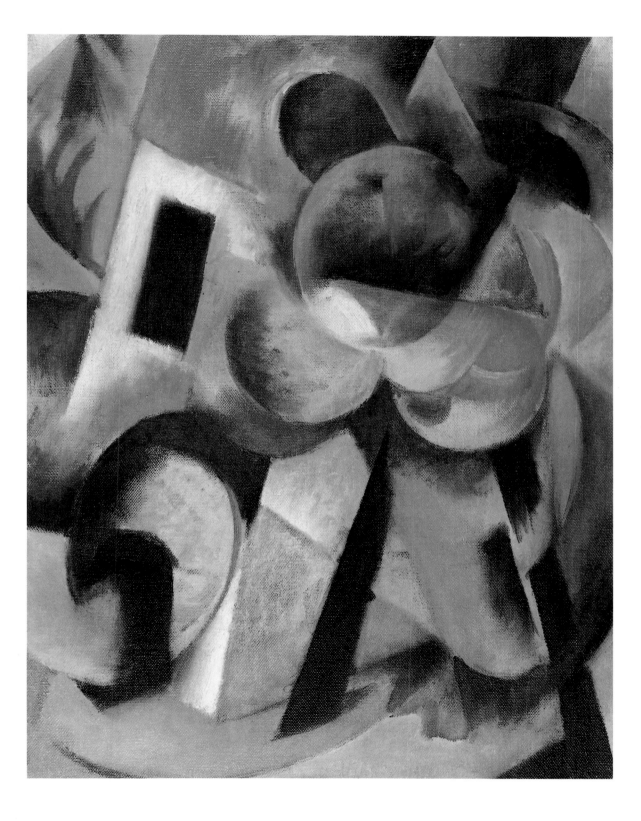

interesting to note that Marc saw these forms in figural terms, so to speak, and understood them as subjects. He thus once more retracted abstraction. In *Fighting Forms,* the red field on the left can – according to Levine – be seen as an eagle, which is attacking a blue-black, otherwise undefinable being.

The ambivalent nature of the artist's feelings emerges even more clearly from the two "representational" works which were the last to be painted/revised in Ried. Marc painted *Tyrol* (p. 77) at the same time as *The Poor Land of Tyrol* (p. 73), soon after his trip to the region. *Tyrol* was also briefly exhibited at the Autumn Salon, before being withdrawn by the artist. He reworked it and added the Madonna on the crescent moon at the centre of the picture. She stands amidst the towering mountains, which taper menacingly into sharp peaks. Beams radiating from the Madonna dissect these mountains at right angles. A few houses crouch in the valley far below, threatened by the mountains and a tree projecting diagonally across the picture, its form recalling a scythe. Behind the mountains in the top right-hand corner rises a darkened sun; facing it, in the top left-hand corner, are a number of crescent moons.

Scythe and Madonna remind us of motifs employed in Christian portrayals of the Apocalypse as told in the Revelation of St. John. The atmosphere of impending doom is translated into this picture in a more direct form than in the previous abstract paintings, above all through the figure of the Madonna which was added in 1914. It furthermore displays a religiosity with a thematic prominence seen – with the exception of his Bible illustrations – nowhere else in Marc's oeuvre, and one which serves as a reminder of the Christian orientation of his childhood. Marc returned to the "other side", the idyll, in his last painting, *Deer in the Woods II* (p. 79). Happiness is sublimely captured in a family scene in

Stables, 1913
Stallungen
Oil on canvas, 73.5 x 157.5 cm
New York, Solomon R. Guggenheim
Museum

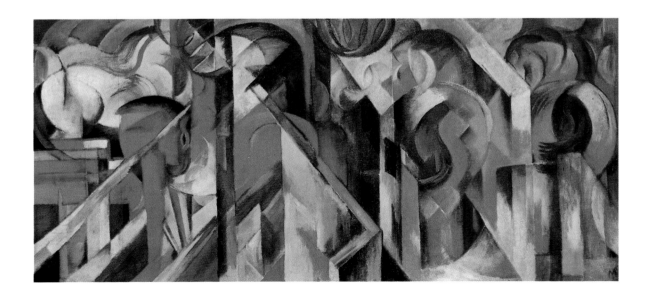

from the field, asking her to see to their publication. In these texts, as in the letters to his wife, it becomes clear that he believed Europe was sick and could only be purged through war. He spoke of an international blood sacrifice through which the world would be purified. He strictly rejected the view that economic interests had led to the War. He understood this War as a civil war, a "war against the inner, invisible enemy of the European spirit".

On the other hand, he also believed that Germany would emerge strengthened from the War, and imagined a Europe under German hegemony. "Germanity will spill across every border after this war. If we want to stay healthy and strong and retain the fruits of our victory, we need. . .a life-force which penetrates all, without fear. . .of the unknown,. . .which will bring us our position of power in Europe."[32]

Even the death of Macke in October 1914 was unable to change his attitude, despite the personal suffering caused by the loss of his friend. In a spontaneously composed obituary, published only after the War and often quoted, he both mourns for his dead friend and at the same time insists upon the necessity of his sacrifice: "The blood sacrifice which turbulent nature demands of nations in great wars they offer with tragic enthusiasm, without regret. The whole clasps loyal hands and bears the loss proudly under peals of victory."[33]

Story of Creation I, 1914
Schöpfungsgeschichte I
Woodcut, 23.8 x 20 cm
Munich, Staatliche Graphische
Sammlung

In his now famous "Briefe aus dem Feld" (Letters from the Field), first published in 1920, these ideas continue to resound, particularly in response to the – sadly unpublished – letters he received from Maria Marc, who was apparently unable to see this positive side of war. But Marc's letters also reveal him confronting other intellectual issues. He had only packed St. Mark's Gospel in his kit bag; he soon asked for other books and discussed their content with Maria in their correspondence. His thoughts revolved constantly around art. He compared the French villages through which he rode with Impressionist paintings and pictures by van Gogh. Marc's 1915 summary of his own artistic efforts, in which he named the reasons for his interest in animals and his later move towards abstract art, is discussed above in the chapter entitled "The animal painting".

His thoughts also strayed constantly back to Ried, to the house and animals. He even gave advice on how they should be fed and was inconsolable when one of the deer died.

As time went on, however, his attitude towards the War altered, a change of heart which many others – including Max Beckmann, to name but one – were also experiencing. In October 1915 he wrote to Lisbeth

"Constant meditation on form, a constant will to form which must be continuously corrected, rejected, reapplied, using all the means in the world as well as personal experience – you cannot get around these. Simply living, feeling life to the core, waiting for form as a flower waits for spring – that never has been and never will be productive art. The actual *work* should, to be sure, make you entirely forget the obstacles along the way. The viewer only can and only should see the pure work; our difficulties don't concern him at all, and nor do our 'means'." *Franz Marc, 29.3.1915*

Fighting Forms, 1914
Kämpfende Formen
Oil on canvas, 91 x 131 cm
Munich, Staatsgalerie moderner Kunst

Macke describing the War as the "cruellest catch of men to which we have abandoned ourselves". To Maria, at New Year 1916, he was even more specific: "The world is richer by the bloodiest year of its many-thousand-year history. It is terrible to think of; and all for *nothing*, for a misunderstanding, for want of being able to make ourselves tolerably *understood* by our neighbours! And that in Europe!! We must unlearn, re-think absolutely everything in order to come to terms with the monstrous psychology of this deed and not only to hate, revile, deride and bewail it, but to understand its origins and to form *counterthoughts.*"[34]

At the beginning of 1916 there was some hope that Franz Marc would soon be sent home. In a letter of 4 March, he wrote to Maria: ". . .yes, this year I will be coming home to my unscathed, beloved home, to you and to my work. Amongst the boundless, horrific pictures of destruction among which I now live, the thought of returning home has an aura which cannot be sweetly enough described."[35]

Franz Marc was hit by shell fire during a reconnaissance expedition that same afternoon. His corpse was buried next morning in the garden of the château of Gussainville. In 1917 Maria had his body transported to Kochel, where he lies buried today.

Else Lasker-Schüler composed an obituary for her friend:
"When the blue rider had fallen. . .
Our hands grasped like rings; -
Our mouths kissed like brothers.
Our eyes became harps
As they wept: heavenly concert.
Now are our hearts orphan angels.
His deeply-wounded godhead
Is extinguished in the picture: Animal destinies."[36]

In autumn 1916 the Munich Neue Sezession held a memorial exhibition – astonishing in so far as Marc had always resisted becoming a member. It provided the most comprehensive overview of his work ever shown. Before the end of 1916 Walden also exhibited works by his friend from the collections of Maria Marc and Bernhard Koehler in his "Sturm" gallery.

After the War, museums began to turn their attention to Marc. The most important purchase was undoubtedly that of *The Tower of Blue*

Sketchbook from the Field, 1915
Skizzenbuch aus dem Felde
Pencil, 16 x 9.8 cm / 9.8 x 16 cm
 respectively
Munich, Staatliche Graphische
Sammlung
Sheet 12: *Arsenal for a Creation*
Sheet 20: *Untitled*
Sheet 21: *Magical Moment*
Sheet 30: *Fragment*

rapidly sealed. Macke draws the attention of Berlin manufacturer Bernhard Koehler to Marc's work. Koehler travels to Munich in February to visit Marc's first exhibition at Brakl's gallery; he buys a number of works, including *The Dead Sparrow* not originally intended for sale. Publisher Reinhard Piper also purchases a lithograph from this exhibition. The subsequent contact between painter and publisher results in close co-operation over the following years.
In April Franz Marc and Maria Franck move permanently to Sindelsdorf. Koehler agrees to pay the artist a monthly 200 Marks and receives half his pictures in return. The contract is provisionally concluded for one year. Marc is thereby freed of material cares.
In autumn he writes an enthusiastic review of the second exhibition of the New Artists' Association. This leads to contact with its members. He feels his painting is now on the right track. Pictures from this period include *Grazing Horses I* and *Horse in a Landscape.*

1911 At New Year, at Alexei von Jawlensky and Marianne von Werefkin's, he meets Wassily Kandinsky and Gabriele Münter. Close contact develops, particularly since Murnau and Sindelsdorf are not far apart.
Marc has meanwhile abandoned plein-air painting. He produces such – today famous – works as *Blue Horse I, The Bull* and *The Yellow Cow.*
In response to the *Protest by German Artists,* which fears the foreign influencing of German art, Marc and Kandinsky organize the publication of *The Battle for Art,* in which well-known museum directors and artists voice their opinions.

Maria and Franz Marc, Bernhard Koehler, Heinrich Campendonk, Thomas von Hartmann; seated: Wassily Kandinsky, 1911

Franz Marc, around 1912

Marc's second exhibition is held in May, this time at Thannhauser's. He and Maria subsequently go to London to get married. Although this marriage is not recognized de jure in Germany, from this point on they live de facto as man and wife.
In a letter to Marc, Kandinsky puts down his first thoughts on a Blaue Reiter almanac; the name is invented in September. In December, shortly before its annual exhibition, Kandinsky, Marc and Münter resign from the New Artists' Association. They quickly organize the first, epoch-making exhibition by the "Editors of *Der Blaue Reiter".*

1912 This year Marc accompanies his wife to Berlin for New Year. He meets the artists of Die Brücke and immediately selects some of their prints to send back to Munich, where the second (and last) *Blaue Reiter* exhibition is to be held in February at Goltz's gallery. This time, however, only graphic works are shown. Paul Klee is also represented. The *Blaue Reiter* almanac finally appears in May. In Berlin, Herwarth Walden exhibits the Munich artists as "German Expressionists".
In autumn the Marcs travel to Bonn to visit the Mackes and the Sonderbund exhibition. Together with August Macke they go to Paris, where they meet Robert Delaunay. Upon their return to Bonn, Marc is offered the opportunity to help hang the Futurist exhibition in Cologne. He is greatly im-

pressed by both Delaunay and the Italian Futurists and his works subsequently reflect their influence.

1913 The Marcs travel to South Tyrol in spring; *The Poor Land of Tyrol* and *Tyrol* are painted shortly afterwards. In June the couple are finally married under German law. This summer Marc paints the large pictures *The Tower of Blue Horses, Animal Destinies* and others.
He also plans to publish an illustrated edition of the Bible together with Wassily Kandinsky, Alfred Kubin, Paul Klee, Erich Heckel and Oskar Kokoschka.

1914 At the end of April the Marcs move to their own house in Ried, near Benediktbeuren. Marc's last large paintings, part representational, part abstract, are produced here. In August Marc, like Macke, immediately volunteers for active service. Macke is killed in October, a painful loss for Marc.

1915 Marc writes many letters to his wife, subsequently published in 1920. He also composes three essays and aphorisms. Since he is not able to paint – only one small sketchbook has survived – he expresses himself in writing.

1916 In February it seems hopeful that Marc, whose attitude to the War has now greatly changed, may be discharged early. On 4 March he is hit by shell fire during a reconnaissance mission. In 1917 his body is transported to Kochel am See, where he lies buried today.

Maria and Franz Marc; on leave from the front, 1915

Notes

1 21 June 1900; quoted from: *Franz Marc 1880–1916.* Städtische Galerie im Lenbachhaus exhibition catalogue. Munich, 1980 (cited below as: Lenbachhaus exh. cat.), p. 15

2 20.10.1905 to Marie Schnür; quoted from: Klaus Lankheit: *Franz Marc, Sein Leben und seine Kunst.* Cologne 1976 (cited below as: Lankheit 1976), p. 28

3 Quoted from: Lenbachhaus exh. cat., p. 28

4 Quoted from: Lenbachhaus exh. cat., p. 22

5 August Macke/Franz Marc: *Briefwechsel.* Edited by Wolfgang Macke, Cologne 1964 (cited below as: Macke/Marc), p. 12

6 Macke/Marc, p. 14

7 Klaus Lankheit (ed.): Franz Marc. *Schriften.* Cologne 1978 (cited below as: *Schriften*), p. 126 ff.

8 Quoted from: Lenbachhaus exh. cat., p. 29

9 Macke/Marc, p. 25; the following quotations ibid., pp. 25–48

10 Quoted from: Schriften, p. 129

11 Quoted from: Schriften, p. 98

12 Quoted from: Schriften, p. 99 f.

13 Quoted from: Schriften, p. 112 f.

14 *Franz Marc: Briefe aus dem Feld.* Edited by Klaus Lankheit and Uwe Steffen, Munich 1986 (cited below as: Briefe aus dem Feld), p. 64 f.

15 Lankheit 1976, p.120

16 Quoted from: *Schriften,* p. 101

17 *Briefe aus dem Feld,* p. 65

18 W. Kandinsky: "Der Blaue Reiter" (Rückblick). 1930, in: Paul Vogt: *Der Blaue Reiter.* Cologne 1977

19 *Der Blaue Reiter.* Edited by Wassily Kandinsky and Franz Marc. New documentary edition by Klaus Lankheit. Munich/Zürich 1984 (cited below as: *Der Blaue Reiter*), p. 180

20 *Der Blaue Reiter,* p. 31

21 *Der Blaue Reiter,* p. 35 f.

22 *Schriften,* p. 102

23 Quoted from: *Expressionisten. Die Avantgarde in Deutschland 1905–1920.* Exhibition catalogue, Nationalgalerie in Berlin (GDR), 1986, p. 109

24 Schriften, p. 109

25 Franz Marc, Else Lasker-Schüler: *"Der Blaue Reiter präsentiert Eurer Hoheit sein Blaues Pferd". Karten und Briefe.* Edited and annotated by Peter-Klaus Schuster. Munich 1987

26 *Briefe aus dem Feld,* p. 50

27 Quoted from: Lankheit 1976, p. 111

28 Macke/Marc, p. 179

29 Lenbachhaus exh. cat., p. 43

30 Lenbachhaus exh. cat., p. 179

31 Macke/Marc, p. 188

32 *Schriften,* p. 161

33 *Schriften,* p. 156

34 *Briefe aus dem Feld,* p. 128

35 *Briefe aus dem Feld,* p. 150 f.

36 Quoted from: Lankheit 1976, p. 157

The publishers wish to thank all those museums, collectors and archives who kindly supplied photographic originals.
The illustrations on the following pages were provided by courtesy of the owner named in the caption: 1, 2, 6, 7, 10, 11, 17, 18, 19, 22, 24, 25, 27, 34/35, 36, 38, 41, 43, 48, 51, 57, 58, 60/61, 62, 64, 66, 70, 74, 75, 79, 81, 82, 84, 85, 90, 92, 93; further sources of illustrations: Nuremberg, Germanisches Nationalmuseum: 95 above and below right; Artothek, Peissenberg: 9, 12, 13, 14, 15, 16, 21, 29, 31, 32, 33, 39, 42, 45 (photograph of a Hanfstaengl collotype of the original, missing since WWII), 52, 63, 65, 68, 69, 72, 73, 77, 80, 83, 88/89, 91, 94; Colorphoto Hans Hinz: 71; publisher's archives: 30, 37, 40, 44, 46, 47, 49, 50, 53, 54, 78, 86, 87, 95 below left. The illustration on p. 56 was taken from the catalogue "Franz Marc 1880–1916", Munich 1980, by kind permission of the Galerie im Lenbachhaus, Munich.